Design fundamentals

NOTES
on VISUAL
ELEMENTS
& PRINCIPLES of
COMPOSITION

Design Fundamentals: Notes on Visual Elements and Principles of Composition

Rose Gonnella, Christopher J. Navetta, and Max Friedman

Peachpit Press

Find us on the Web at www.peachpit.com
To report errors, please send a note to errata@peachpit.com

Peachpit Press is a division of Pearson Education.

Acquisitions Editor: Nikki Echler McDonald
Series Editor: Rose Gonnella
Production Editor: Tracey Croom
Copy Editor: Jan Seymour
Indexer: James Minkin
Cover Design: Max Friedman
Primary Illustrator: Max Friedman
Design: Max Friedman, Christopher J. Navetta, and Rose Gonnella

ISBN 13: 978-0-133-93013-9
ISBN 10: 0-133-93013-0

9 8 7 6 5 4 3 2 1

Printed and bound in the United States of America

→ THIS BOOK IS DEDICATED TO THE SPLENDIFEROUS STUDENTS of THE ROBERT BUSCH SCHOOL OF DESIGN AT KEAN UNIVERSITY.

For more content, visit **design-fundamentals.com** and our PInterest boards at **pinterest.com/dsnfundamentals**

Special thanks to Nikki McDonald and Robin Landa
Much appreciation to Hayley Gruenspan, Hannah Friedman, and Jean-Marie Navetta

And to the students of the Robert Busch School of Design, our sincere appreciation for their contributions:
Margaret Grzymkowski, Kyle Godfrey, Lillianna Vazquez, John Weigele, Alexa Matos, Maria Finelli, and Nancy Fuentes

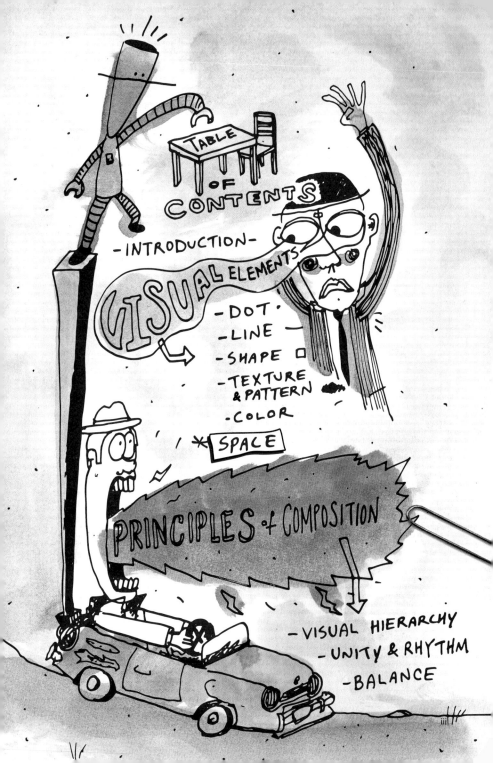

ES, SHAPES, FORMS,
ES, PATTERNS, COLORS,
CE — THE VISUAL ELEMENTS
OF DESIGN COMPRISE
THE PHYSICAL
ENVIRONMENT
ALL AROUND US

NO DIVING

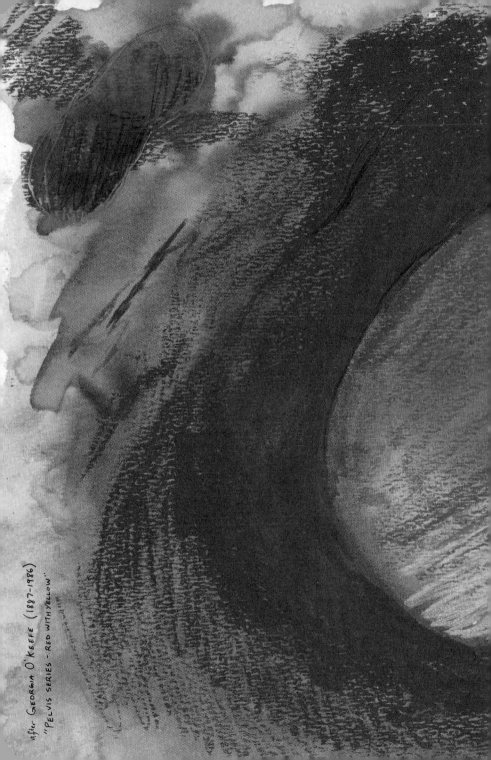

after GEORGIA O'KEEFE (1887-1986)

"PELVIS SERIES - RED WITH YELLOW"

TERMS VARY

NOT ALL ARTISTS, DESIGNERS, WRITERS, AND CRITICS AGREE ON WHAT CONSTITUTES THE BASIC VISUAL ELEMENTS & PRINCIPLES OF COMPOSITION. TERMS VARY AS WELL.

FOR SOME, THE WORD "FORMAL" REPLACES "VISUAL," REFERRING TO THE BASIC ELEMENTS.

SOME SEPARATE "Space" INTO ITS OWN CATEGORY BETWEEN ELEMENTS AND PRINCIPLES.

OTHERS CONSIDER DOT, LINE, AND FORM TO BE ONE ELEMENT, SUBSETS OF SHAPE.

A SUBSET OF COLOR, VALUE → (SHADES OF GRAY) CAN BE SEEN AS DISTINCT ENOUGH TO SEPARATE INTO A VISUAL ELEMENT APART FROM COLOR.

~ THE TERMS FOR THE PRINCIPLES ALSO VARY ~

THE WORD "CONTRAST" SOMETIMES REPLACES THE WORD HIERARCHY. HARMONY IN SOME DISCUSSIONS REPLACES THE WORD UNITY. THE SINGLE TERM FOR THE OVERALL SUCCESSFUL COMPOSITION OF THE ELEMENTS IS ALSO HARMONY.

DESPITE THE VARIATIONS (THERE ARE MORE), WITH ANY DISCUSSION OF THE VISUAL ELEMENTS AND THE PRINCIPLES OF COMPOSITION, THE OUTCOME IS THE SAME:

SUCCESS IN DESIGN.

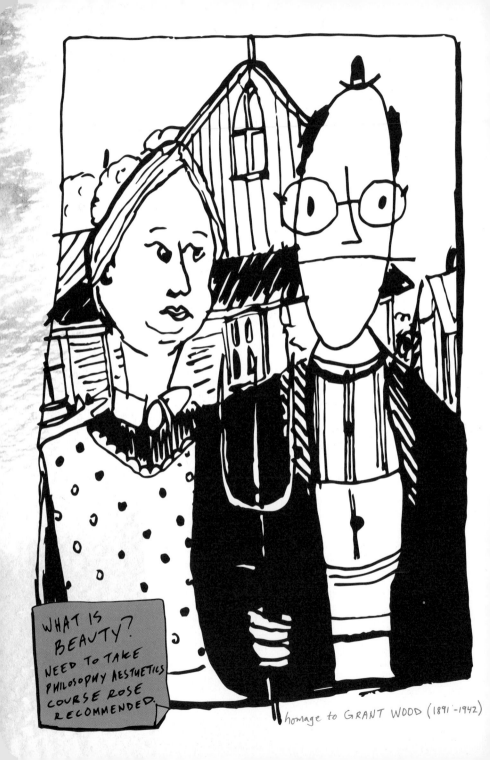

WHAT IS
BEAUTY?
NEED TO TAKE
PHILOSOPHY AESTHETICS
COURSE ROSE
RECOMMENDED.

homage to GRANT WOOD (1891 -1942)

after PAUL RAND

DESIGN

SELECTS, BORROWS, SIMPLIFIES, TRANSLATES, SYNTHESIZES, & REORDERS VISUAL ELEMENTS 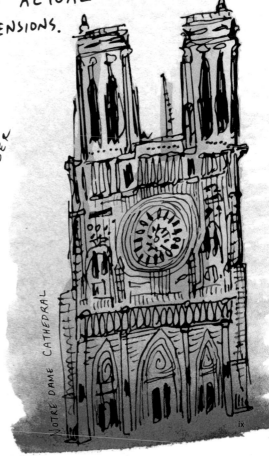 INTO TIGHT, BEAUTIFULLY ORCHESTRATED COMPOSITIONS ON THE FLAT PLANE OF **TWO** DIMENSIONAL SURFACES OR IN ACTUAL **THREE** DIMENSIONS.

HIERARCHY, BALANCE, UNITY, AND RHYTHM — THESE ARE THE GUIDING PRINCIPLES OF COMPOSITION THAT BRING PHYSICAL ORDER TO THE DESIGN.

NOTRE DAME CATHEDRAL

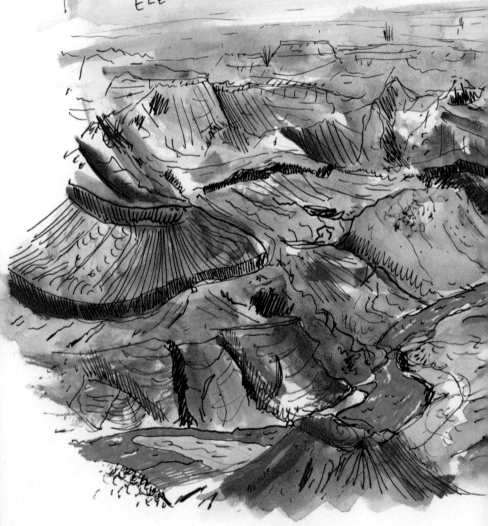

THE GRAND CANYON IS A COMPLEX
TEXTURES, PATTERN, AND SPACE — A
ELEMENTS CREATED IN NATURE.

COMPOSITION OF DOTS, LINES, SHAPES, FORMS, COLORS,
COINCIDENTAL ARRANGEMENT OF VISUAL

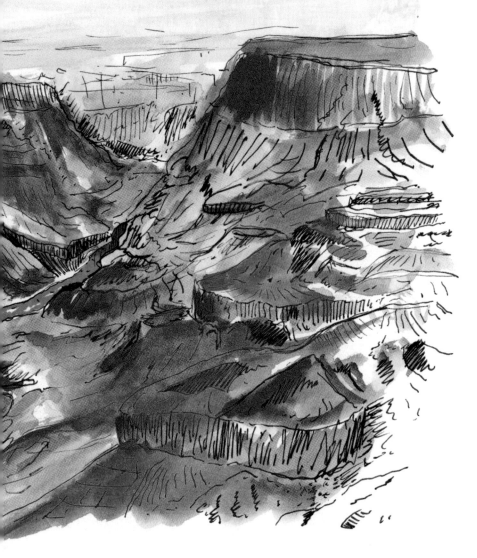

OUR EFFORTS TO MAKE IMAGES, DELIVER INFORMATION, & CREATE OBJECTS, ENVIRONMENTS, AND STRUCTURES— TO **DESIGN**— IS NOT COINCIDENTAL.

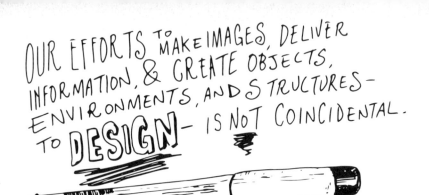

UNLIKE THE RANDOM COINCIDENCES FOUND IN NATURE, HUMANS EMPLOY THEIR SENSES, MIND, & HEART AS THE DECISION MAKERS IN THE PROCESS OF COMPOSING IMAGES, INFORMATION, OBJECTS, AND STRUCTURES—

WHETHER WITH A CAMERA OR COMPUTER, OR A PAINTING OR SCULPTURE, OR WITH ANY OTHER MEDIUM.

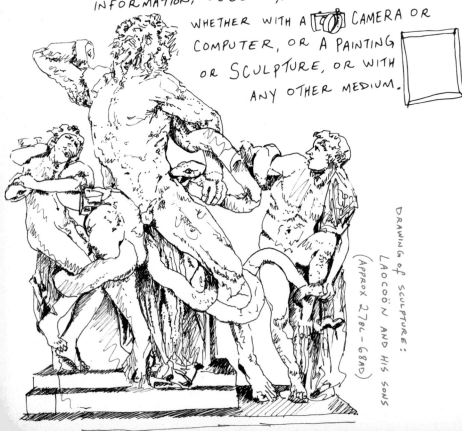

DRAWING of SCULPTURE: LAOCOÖN AND HIS SONS (APPROX 27BC – 68AD)

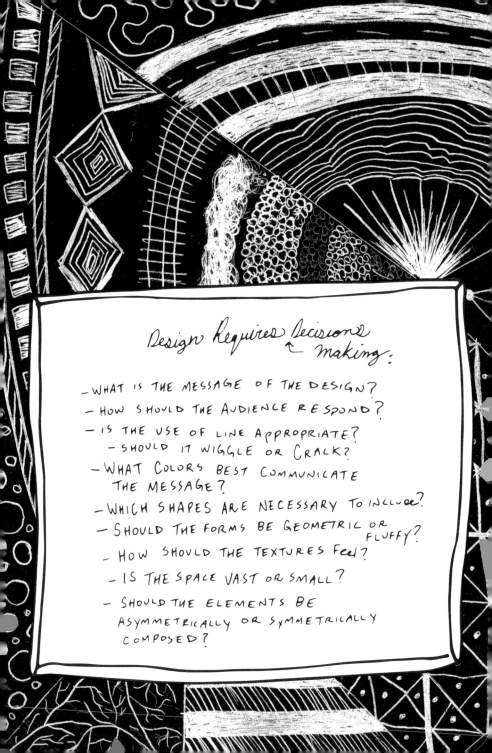

Design Requires Decisions ← making:

- WHAT IS THE MESSAGE OF THE DESIGN?
- HOW SHOULD THE AUDIENCE RESPOND?
- IS THE USE OF LINE APPROPRIATE?
 - SHOULD IT WIGGLE OR CRACK?
- WHAT COLORS BEST COMMUNICATE THE MESSAGE?
- WHICH SHAPES ARE NECESSARY TO INCLUDE?
- SHOULD THE FORMS BE GEOMETRIC OR FLUFFY?
- HOW SHOULD THE TEXTURES FEEL?
- IS THE SPACE VAST OR SMALL?
- SHOULD THE ELEMENTS BE ASYMMETRICALLY OR SYMMETRICALLY COMPOSED?

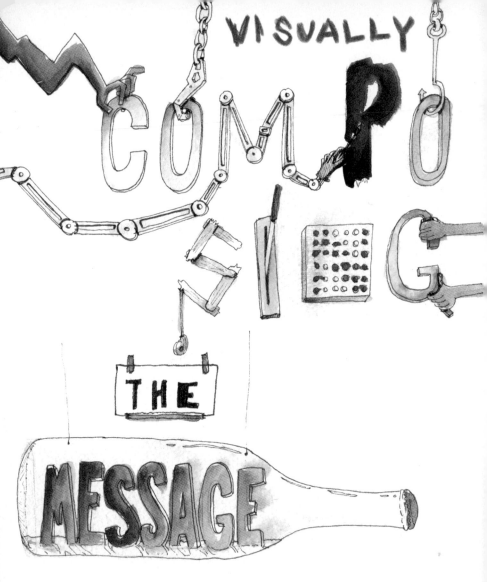

THE PURPOSEFUL COMPOSITION OF THE VISUAL ELEMENTS IS IN SERVICE of THE GRAND PURSUIT OF ORIGINAL, AESTHETICALLY ENGAGING, MEANINGFUL DESIGN TO COMMUNICATE IDEAS, CONCEPTS, COMMENTARY, OR MESSAGES.

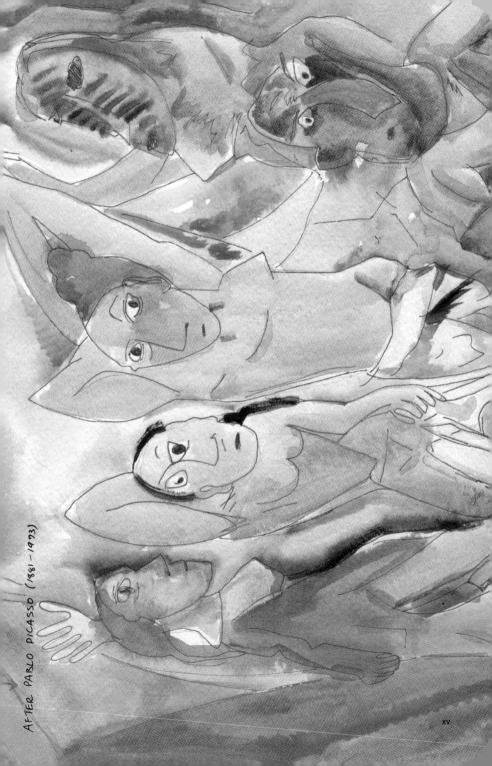

AFTER PABLO PICASSO (1881-1973)

IDEAS & MESSAGES CONVEYED THROUGH DESIGN
CAN BE PERSUASIVELY INFORMATIVE, DEEPLY
PHILOSOPHICAL, A CULTURAL
CRITIQUE, OR SOCIO-POLITICAL.

But design does not
necessarily need
to have a profound
message.

THE MESSAGE
CAN BE
INTENDED
TO
SIMPLY
DELIGHT.

after BEN SHAHN
(1898-1969)
TWO WHISPERING
POLITICIANS

FOR INSTANCE, AN AESTHETICALLY PLEASANT AND BETTER FUNCTIONING TEAPOT DELIGHTS.

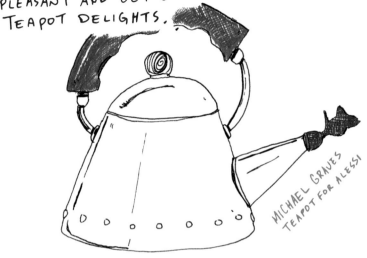

MICHAEL GRAVES TEAPOT FOR ALESSI

ADVERTISING DESIGN CREATIVELY INFORMS THE AUDIENCE OF THE VALUE of A PARTICULAR BRAND.

PRE-EXISTING INDIVIDUAL AND CULTURAL STANDARDS DETERMINE AESTHETICS.
(LIKE THE LAW, Beauty IS WHAT WE SAY IT IS.)

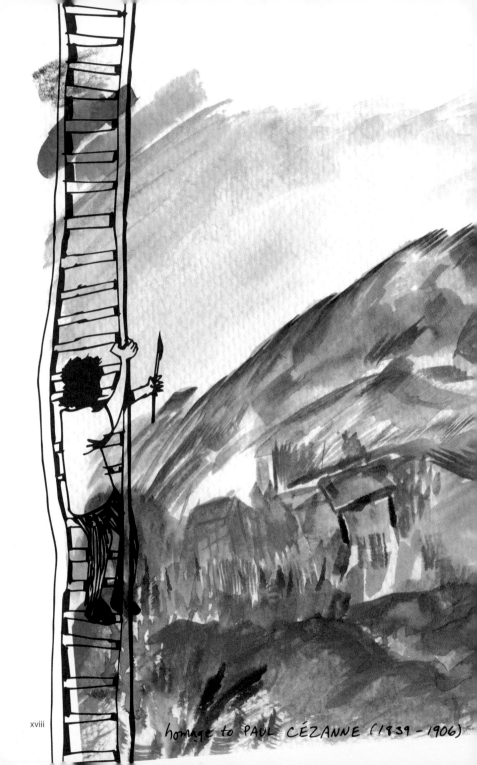

homage to PAUL CÉZANNE (1839 - 1906)

ALTHOUGH ARTISTS AND DESIGNERS WORK WITH ESTABLISHED PRINCIPLES OF DESIGN AND AESTHETIC STANDARDS, THEY OFTEN LEAD THE WAY TO ESTABLISHING NEW FORMS & IDEAS.

BUT, BEFORE YOU CAN BREAK THE RULES, YOU MUST MASTER THE BASICS, WHICH REQUIRES PRACTICAL KNOWLEDGE AND DEMONSTRATED CONTROL OF THE VISUAL ELEMENTS AND PRINCIPLES OF COMPOSITION.

PLAY WITH THE

{BOUNDARIES}

THE CONCEPTUAL ARTIST

MARCEL DUCHAMP

WANTED TO DISRUPT THE STATUS QUO BY CLAIMING ANYTHING IS ART IF THE ARTIST SAYS IT IS — SUCH AS A STOOL WITH A BICYCLE WHEEL PERCHED ON TOP.

FOR HIM, THE DISCUSSION OF THE VISUAL ELEMENTS WOULD BE A BORE AND A DISTRACTION FROM THE MESSAGE.

But DUCHAMP HELD THE KNOWLEDGE of THE VISUAL ELEMENTS AND PRINCIPLES of COMPOSITION SOMEWHERE IN HIS MIND EVEN THOUGH HIS PRIMARY INTEREST WAS WITH THE MESSAGE, NOT THE DESIGN.

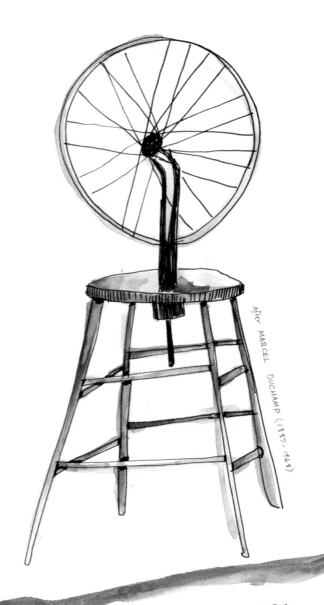

after MARCEL DUCHAMP (1887-1968)

IDENTIFY THE GUIDELINES THAT DESCRIBE THE VISUAL ELEMENTS, BE ABLE TO ANALYZE ESTABLISHED "RULES" GOVERNING THE PRINCIPLES OF COMPOSITION, AND RECOGNIZE THE BOUNDARIES — THEN GO AHEAD AND BREAK THE RULES, PLAY WITH BOUNDARIES, AND...

DOT:
AN
ELE
MENT.

A DOT IS THE SMALLEST VISUAL ELEMENT.

·

A DOT IS A SPOT, SPECKLE, MARK, OR A FRECKLE, WITH
A DIFFERENT COLOR FROM THAT WHICH SURROUNDS IT.

A DOT IS NOT ALWAYS CIRCULAR OR GEOMETRIC. AN
IRREGULAR BLOB OF INK, CLAY, OR PAINT IS ALSO A DOT.

A DOT ON A SCREEN IS A PIXEL, WHICH IS SQUARE.

A DOT CAN BE AN OBJECT: THE NOSE ON YOUR →
FACE, A FLOWER, OR THE MOON AND STARS.

A DOT MULTIPLIED MAY LOOK IRREGULAR LIKE
A BLOB, BUT IT'S STILL A DOT.

A DOT CAN BE VISUALLY ROUGH, DELICATE, ORGANIC, RIGID, AND SO SUGGEST ANGER, HAPPINESS, OR SADNESS.

A DOT IS NOT A POINT; A DOT IS A PLACE.

A DOT PHYSICALLY INDICATES A PLACE ON A DESIGNATED SURFACE OR WITHIN A GIVEN FORMAT.

A DOT IS INHERENTLY STATIC. THEREFORE...

A DOT IS LIKE AN ANCHOR CALLING ATTENTION TO ITSELF WHEREVER IT IS LOCATED.

A DOT IS ALSO THE SMALLEST UNIT OF A LINE.

DOTS ALL WE NEED TO KNOW (FOR NOW).

DOTS FOCUS ATTENTION.

NO DOTS, BUT FULL OF POINTS.

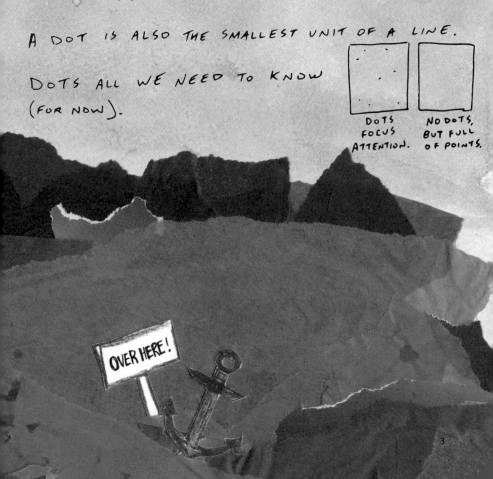

OVER HERE!

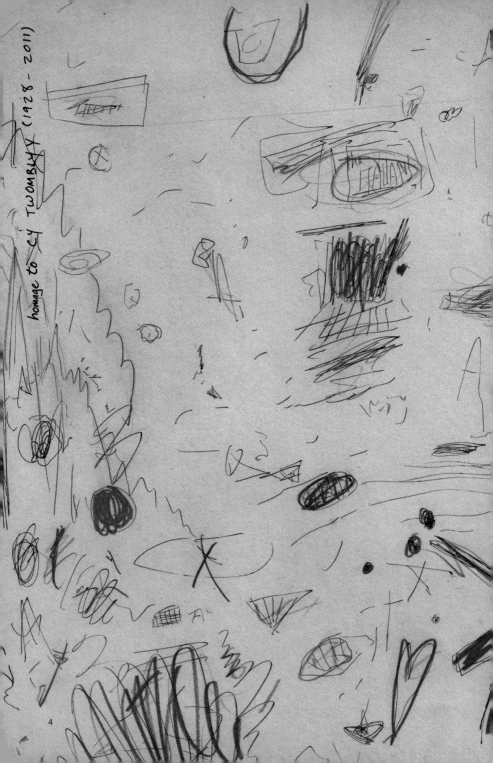

homage to CY TWOMBLY (1928 - 2011)

the ITALIAN

4

ALL YOU NEED IS LINE

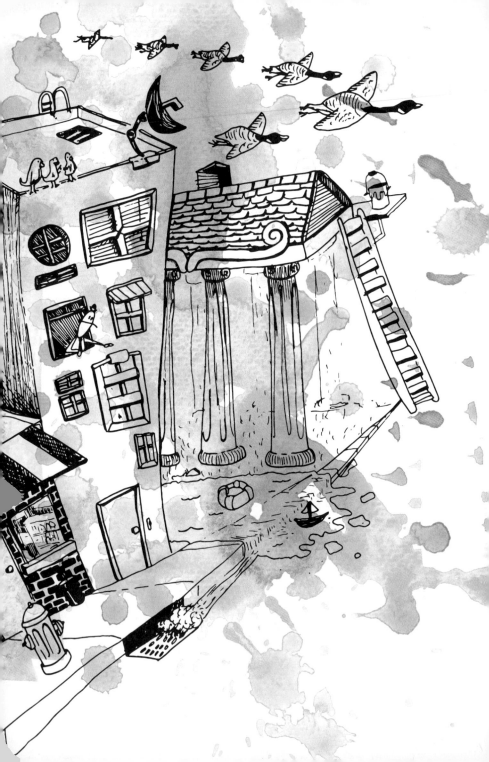

LINE UP ↴

LINES ARE NATURAL.

LINES ARE THE BRANCHES OF TREES.

LINES DEFINE ZEBRAS, AND TIGERS, AND SEASHELLS.

LINES DESCRIBE THE AGE OF THE HUMAN FACE →

LINES COMMUNICATE THROUGH LETTERS,
ICONS, AND SYMBOLS.

LINES ARE MANUFACTURED OF WIRE, STRING,
AND FILAMENT.

LINES TRANSPORT US BY STREETS,
ROADS, RIVERS, AND TRACKS.

LINES ORGANIZE INFORMATION THROUGH GRAPHS,
CHARTS, AND FLOOR PLANS.

LINES ARE NOT ALWAYS PHYSICAL; THE EDGES OF
OBJECTS ARE LINES.

LINES DEFINE THE EDGE BETWEEN OBJECTS SUCH AS
WHERE SKY MEETS WATER.

LINES FORM AT THE BUS STOP ON
A BUSY CITY STREET.

LINES FACTOR SIGNIFICANTLY IN OUR
EVERYDAY LIVES AND ENVIRONMENT.

7

LINE IS A FUNDAMENTAL VISUAL ELEMENT.

YET, LINE IS ITS OWN COMPLEX VISUAL VOCABULARY IN STYLE, FUNCTION, AND EXPRESSIVENESS.

after VINCENT VAN GOGH (1853–1890)
(ONE OF THE GREATEST LINE ARTISTS OF ALL TIME.)

FORMING A LINE

CREATED W/ TRADITIONAL
OR DIGITAL TOOLS AND
CHARACTERIZED AS LONGER
THAN IT IS WIDE,

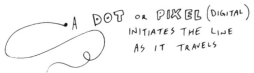

A LINE IS A PATH.

A DOT OR PIXEL (DIGITAL)
INITIATES THE LINE
AS IT TRAVELS

ACROSS A PHYSICAL SURFACE OR

A SCREEN FROM POINT TO POINT AND BACK AGAIN.

UNLIKE THE STATIC NATURE OF A DOT,

A LINE FEELS ACTIVE.

THEREFORE, MOVEMENT AND DIRECTION
ARE GENERAL CHARACTERISTICS OF A LINE.

IN COMPUTER GRAPHICS, A LINE
IS KNOWN AS A STROKE. THE
COMPUTER SOFTWARE GENERATES
A STROKE TO CONNECT TWO
DESIGNATED POINTS OR PIXELS.

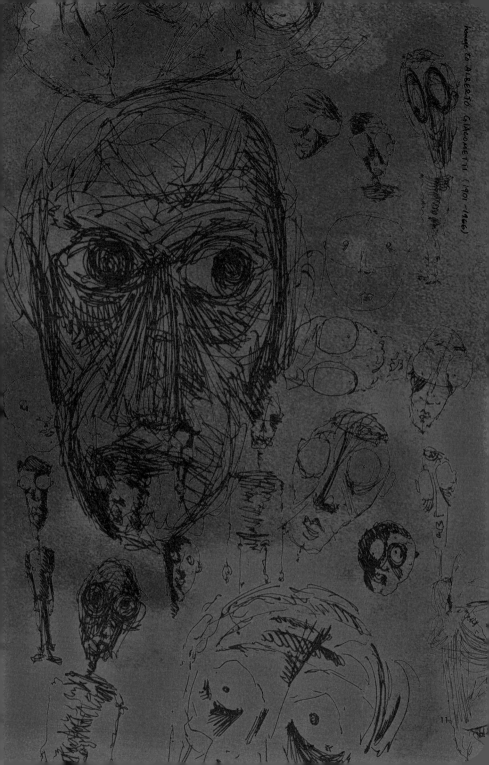

homage to ALBERTO GIACOMETTI (1901 -1966)

FOR EASE of RECOGNITION,
FOR RELEVANT USE,

LINES ARE OF TYPE A

DISCUSSION, AND ANALYSIS
LINES ARE CLASSIFIED BY TYPE:

1.

AN INTERRUPTED LINE

IS A ROW OF MARKS, DOTS, AND DASHES.

- THIS TYPE OF LINE LOOSELY DEFINES AND DIVIDES, SUGGESTING IMPERMANENCE OR OPENNESS.

2.

UNINTERRUPTED LINES

ARE UNBROKEN OR SOLID, BUT NOT NECESSARILY STRAIGHT.

- SOLID LINES HAVE A VARIETY OF GRAPHIC FUNCTIONS DEFINING OBJECTS AND BORDERS AND DIVIDING SPACES.

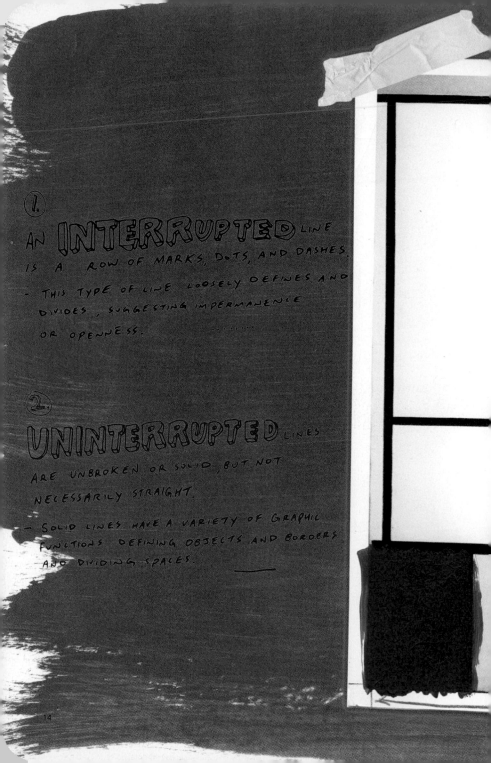

13-125

after PIET MONDRIAN (1872-1944)

(3.) AN **ANGLED** LINE OR **GEOMETRIC** LINE

IS THE CONVERSE OF AN ORGANIC LINE. ANGLED OR GEOMETRIC LINES FEEL MECHANICAL OR RIGID AND CAN CONVEY A SENSE OF STABILITY OR AUSTERITY.

Note on angles

→ ANGLE : THE SPACE (MEASURED IN DEGREES) AT THE POINT OF INTERSECTION BETWEEN TWO PERPENDICULAR, STRAIGHT LINES.

ACUTE ANGLE: SMALLER THAN A RIGHT ANGLE AT LESS THAN 90°

OBTUSE ANGLE: AN ANGLE THAT IS MORE THAN 90°, BUT LESS THAN 180°

RIGHT ANGLE : AN ANGLE AT 90° WHERE THE PERPENDICULAR LINES MEET.

90°

2 3/4"

39%

15

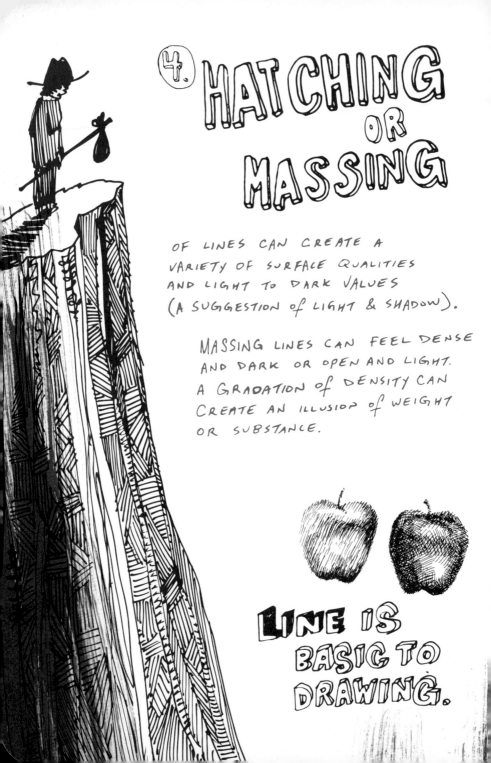

4. HATCHING OR MASSING

OF LINES CAN CREATE A VARIETY OF SURFACE QUALITIES AND LIGHT TO DARK VALUES (A SUGGESTION of LIGHT & SHADOW).

MASSING LINES CAN FEEL DENSE AND DARK OR OPEN AND LIGHT. A GRADATION of DENSITY CAN CREATE AN ILLUSION of WEIGHT OR SUBSTANCE.

LINE IS BASIC TO DRAWING.

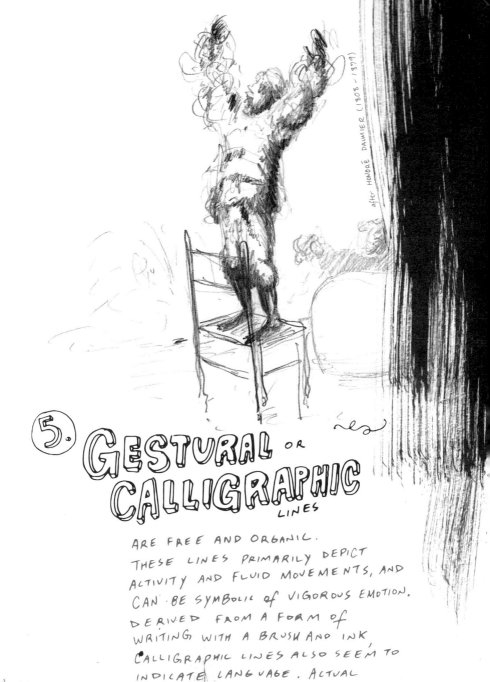

after HONORÉ DAUMIER (1808 - 1879)

5. GESTURAL OR CALLIGRAPHIC LINES

ARE FREE AND ORGANIC.
THESE LINES PRIMARILY DEPICT
ACTIVITY AND FLUID MOVEMENTS, AND
CAN BE SYMBOLIC of VIGOROUS EMOTION.
DERIVED FROM A FORM of
WRITING WITH A BRUSH AND INK,
CALLIGRAPHIC LINES ALSO SEEM TO
INDICATE LANGUAGE. ACTUAL
CALLIGRAPHY IS AN ARTISTIC
FORM OF HANDWRITING.

17

6. an Implied Line

is not an actual line. Implied lines form in the mind's eye of the viewer. The human eye & mind seek to fill in the space between a series of dots to complete the line.

LITTLE DIPPER

BIG DIPPER

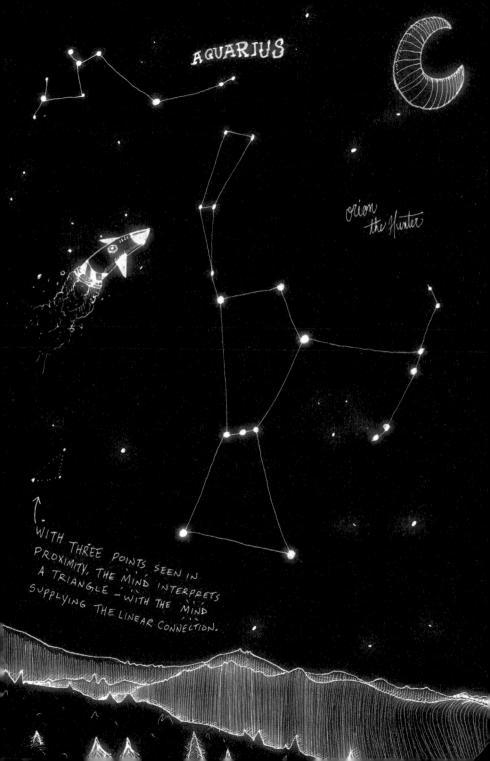

AQUARIUS

orion
the Hunter

WITH THREE POINTS SEEN IN
PROXIMITY, THE MIND INTERPRETS
A TRIANGLE — WITH THE MIND
SUPPLYING THE LINEAR CONNECTION.

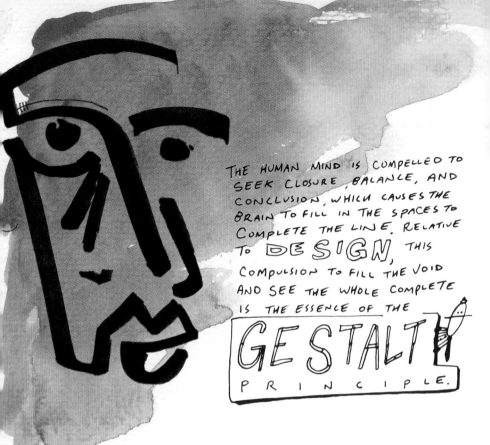

THE HUMAN MIND IS COMPELLED TO
SEEK CLOSURE, BALANCE, AND
CONCLUSION, WHICH CAUSES THE
BRAIN TO FILL IN THE SPACES TO
COMPLETE THE LINE. RELATIVE
TO DESIGN, THIS
COMPULSION TO FILL THE VOID
AND SEE THE WHOLE COMPLETE
IS THE ESSENCE OF THE

GESTALT
P R I N C I P L E.

DERIVED FROM A PSYCHOLOGICAL THEORY
of THE LATE 19th & 20th CENTURIES,
GESTALT PSYCHOLOGY EXPLAINS THIS
COMPULSION AS A SELF-ORGANIZING
EFFORT TO COMPLETE THE WHOLE
BEFORE PERCEIVING THE INDIVIDUAL
ELEMENTAL PARTS — COMPLETION
PROVIDING A SENSE OF ORDER &
CONTENTMENT.

7. EDGES

WITHIN A DESIGN, A CLEARLY DEFINED **EDGE** IS ALSO AN IMPLIED LINE. AN **EDGE** DEFINES AND CREATES A LINE OF MOVEMENT IN AND AROUND A SINGLE OBJECT OR THROUGH THE OBJECTS IN A WHOLE COMPOSITION.

AN EDGE OR AN IMPLIED LINE THAT MOVES THE VIEWER'S EYE AROUND THE COMPOSITION IS REFERRED TO AS THE **LINE OF VISION**. A **COMPOSITIONAL LINE** IS AN ALTERNATE TERM FOR LINE OF VISION.

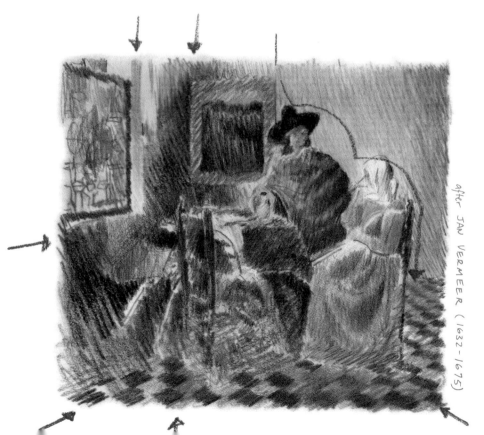

after JAN VERMEER (1632 - 1675)

8. THREE-DIMENSIONAL LINES

EDGES ARE INTRINSIC TO SCULPTURES, OBJECTS, AND ARCHITECTURAL STRUCTURES & ENVIRONMENTS.

after MICHAEL GRAVES (1934–)

3D LINES

ARE ACTUAL OR PHYSICAL. THREE-DIMENSIONAL LINES CAN BE MADE of WIRE, STRING, WOOD, STONE, OR SYNTHETIC FILAMENT. THEY CAN ALSO BE INTERRUPTED OR SOLID, ANGLED OR ORGANIC, MASSED OR IMPLIED.

after
CHARLES RENNIE MACKINTOSH
HILLHOUSE CHAIR
(1868–1928)

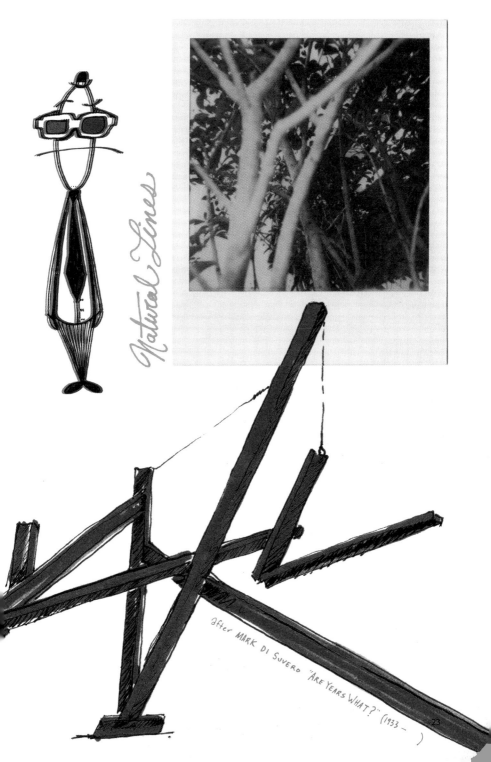

Natural Lines

after MARK DI SUVERO "ARE YEARS WHAT?" (1933 –)

23

LINES have FUNCTIONS

LINES SEPARATE, LINES ISOLATE, LINES DEMARCATE.

AN OUTLINE DESCRIBES THE OUTER EDGES OF AN OBJECT IN A SIMPLIFIED WAY.

A CONTOUR DESCRIBES THE WHOLE OBJECT WITH VARYING DETAIL AND COMPLEXITY.

Lines also give substance to ideas. Rapidly executed, simple line sketches quickly visualize thoughts.

LINES SPEAK AND SING

LINES FORM THE LETTERS IN THE ALPHABET AND NOTES OF MUSIC.

LINES ARE ESSENTIAL TO COMMUNICATION.

LINES HAVE CHARACTERISTICS AND QUALITIES

WHETHER ACTUAL OR TWO-DIMENSIONAL, LINES HAVE QUALITIES AND CHARACTERISTICS IN AND of THEMSELVES AS WELL AS IN RELATIONSHIP TO EACH OTHER.

- CHARACTERISTICS:

 WIDTH: THICK, THIN, GRADUATED

 LENGTH: LONG, SHORT, BLUNT

 POSITION: PERPENDICULAR, PARALLEL, RADIAL

 DIRECTION: HORIZONTAL, VERTICAL, DIAGONAL, ZIGZAG

 - QUALITY:

 FOCUS: SHARP, BLURRY, FAINT

 CONDITION: JAGGED, STRAIGHT, SMOOTH, SERRATED, CHOPPY, CONTINUOUS, CURVING, ANGULAR, ETC.

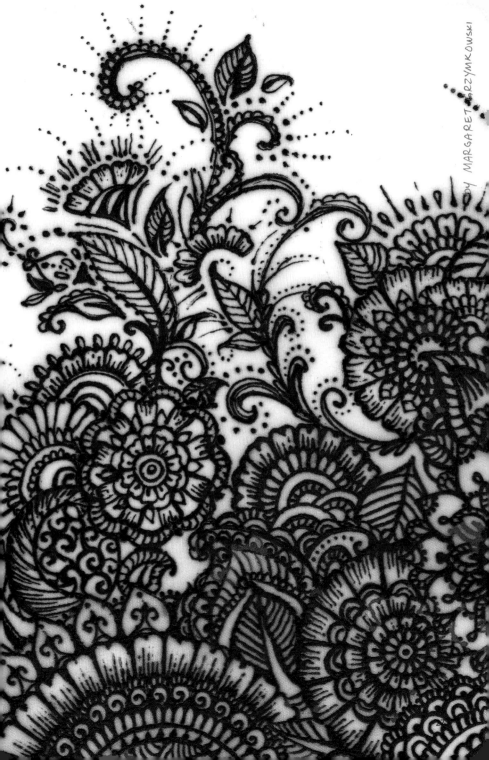

BOTH IN THE MIND OF THE DESIGNER AND THE AUDIENCE, LINES CAN CONJURE ASSOCIATIONS OR COMPARISONS WITH OBJECTS, PLACES, AND EVENTS. WE USE COMPARISON TO HELP US CLARIFY AND DEFINE THE UNKNOWN OR UNFAMILIAR COMPLEXITIES OF THE WORLD AROUND US.

ASSOCIATIONS AND COMPARISONS ARE PERSONAL.

DESIGNERS NEED TO BE AWARE THAT EVERY PERSON HAS THE POTENTIAL TO RESPOND DIFFERENTLY. ONE PERSON WILL SEE A LINE AND COMPARE IT TO A ROAD (MOVEMENT), ANOTHER MIGHT SEE THE SAME LINE AS A BOUNDARY (STATIC).

THERE ARE NO FORMULAS OR ABSOLUTES.

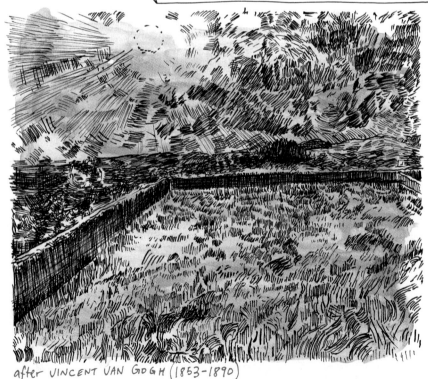

after VINCENT VAN GOGH (1853-1890)

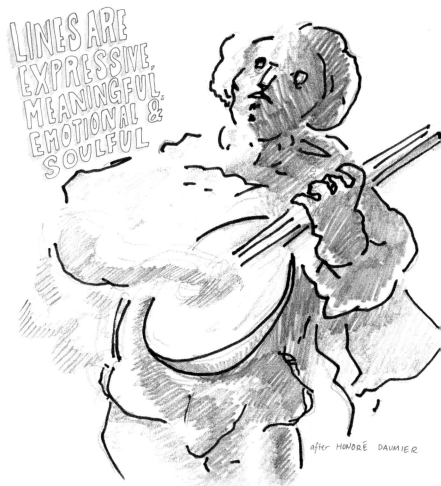

LINES ARE EXPRESSIVE, MEANINGFUL, EMOTIONAL & SOULFUL

after HONORÉ DAUMIER

~THIN~ FRAGILE LINES ✦FEEL✦ LIKE A

CLOUD

~OR~ SOAP BUBBLES

~THICK~ BLUNT LINES ~FEEL~

BOLD

LIKE A ROW OF

BRICKS

29

PARALLEL TO THE EARTH, THE LANDSCAPE'S HORIZONTAL LINES FEEL **STABLE** ⌃ SUGGEST PEACEFULNESS.

Kyle Godfrey

LINES EXTENDING OFF THE EDGES OF THE FORMAT SUGGEST INFINITY.
(WHEN THE FORMAT IS ALSO HORIZONTAL, THE FEELING IS ENHANCED.)

MASSING LINES SUGGEST
A FEELING of SOLIDITY.

31

A SINGLE DIAGONAL LINE STRETCHED ACROSS THE PAGE OR SCREEN FEELS UNSTABLE, MUCH LIKE BEING IN AN AIRPLANE THAT IS TURNING IN SPACE.

BECAUSE THEY ARE PERPENDICULAR TO THE
EARTH, VERTICAL LINES HAVE A FEELING
OF HEIGHT, OR A SENSE OF EXTENDED
REACH TO THE SKY.

THICK VERTICAL
LINES SUGGEST POWER.

ZIGZAGGING LINES CURVING AROUND
THEMSELVES SUGGEST A FEELING OF ANXIETY.

after BERTHOLD LÖFFLER (1874–1960)

CURVING, THIN, TAPERING LINES
SUGGEST A SENSE OF GRACEFUL
MOVEMENT LIKE THE ARMS OF
A BALLET DANCER.

LINES OF COLOR

LINES COMBINED WITH A COLOR ALLOW FOR GREATER COMPLEXITY OF IDEAS OR EMOTIONS.

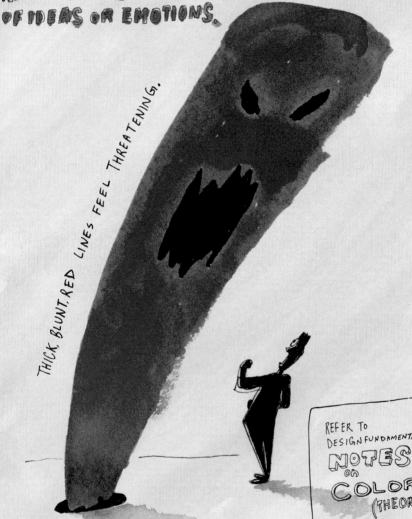

THICK, BLUNT, RED LINES FEEL THREATENING.

REFER TO DESIGN FUNDAMENTALS:

NOTES ON COLOR (THEORY)

FOR IN-DEPTH EXAMINATION OF COLOR.

MIXED MEDIA, TOOLS... AND STUFF. (FOR CREATING LINES)

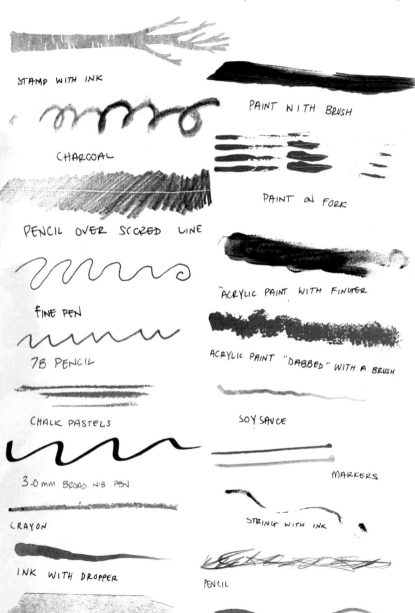

STAMP WITH INK

CHARCOAL

PENCIL OVER SCORED LINE

FINE PEN

7B PENCIL

CHALK PASTELS

3.0 mm BROAD NIB PEN

CRAYON

INK WITH DROPPER

TAPE

PAINT WITH BRUSH

PAINT ON FORK

ACRYLIC PAINT WITH FINGER

ACRYLIC PAINT "DABBED" WITH A BRUSH

SOY SAUCE

MARKERS

STRING WITH INK

PENCIL

BRUSH TIP MARKER

37

AND THAT'S THE BOTTOM LINE.

SUMMARY

Line— the most fundamental of the visual elements— is also both complex and versatile. You must be able to recognize the types, functions, character, and qualities of line and be able to make critical decisions for its functional, compositional, and conceptual use to create effective designs.

EXERCISES
& PROJECTS

1. LINE QUALITY

INDIVIDUAL ACTIVITIES

A. MUSICAL LINES: Listen to music and interpret the sounds as lines.

SUPPLIES: Traditional imaging tools and extra large sheets of paper or a large digital drawing tablet.

COMPOSE AND SHARE RESULTS

- Select a range of music from which to draw lines: classical, movie sound tracks, rock, alternative, country, folk, jazz, blues, etc.

- Organize the music in order to listen to it continuously without having to stop the drawing activity.

- Place the traditional tools on the tabletop so that they are ready to use as needed.

- As the music plays, interpret the sound with lines using line's types, functions, and expressive qualities.

- Allow for free and uninhibited interpretations. This exercise is completely subjective and personal. There are no correct or incorrect ways to interpret the music. The outcome is to demonstrate the rich vocabulary of line.

- Make a video to record the exercise.

- Present results on paper and share the video.

B. BLIND CONTOUR: In this exercise, practice contour drawing, but without looking at the substrate. Focus on seeing.

SUPPLIES: Medium point marker. Appropriate paper.

COMPOSE AND SHARE RESULTS

- Research historic residential architecture of the following periods: Victorian, Art Nouveau, Arts & Crafts, and Craftsman.

- Select one style, and from that style choose several examples as models.

- Draw each of the examples as a contour. However, do not lift your hand or look at the paper or screen while drawing. This method forces concentration on the contour line rather than exacting proportions and representation.
- Optional: Select one of the blind contour drawings and add some color.
- Share results for group observation.

GROUP ACTIVITY

C. LINE INSTALLATION: Create an environmental installation using color tape or yarn.

See the work of contemporary artists such as Jim Lambie.

Allow the installation to be purely experimental, arranging the lines freely without a specific application in mind.

SUPPLIES: Color tape or yarn and pushpins, colored pencil or marker, paper or graphics software.

Select an appropriate and safe environmental space. Be sure to gain permission for use of the space.

COMPOSE AND SHARE RESULTS

- Select team members. Optional: Video the process.
- Photograph and use a still image of the environment. Print multiple copies of the image on which to draw potential arrangements.
- Sketch ideas for the installation using lines drawn with colored pencil or marker or digital tools on screen.
- Install the actual lines in the environment using yarn or color tape to represent the lines.

2. LINE IN APPLICATION

GROUP ACTIVITY

A. MASTER LINE: Research, organize, and summarize the underlying intent of the use of line in the creative work of master artists, architects, and designers.

SUPPLIES: Computer and Internet/Web access.

COMPOSE AND SHARE RESULTS

- Research master works on museum websites such as The Getty, MoMA, The Met, and The Cooper Hewitt National Design Museum.
- Identify and select master works that use line as the primary element.
- Exemplify line types, functions, character, and qualities.
- Find examples of line manufactured or natural objects.
- Share the archive with the class on Pinterest or in a group digital file system.

INDIVIDUAL ACTIVITY

B. LINE OF VISION IN APPLICATION: Identify line of vision in the works of art and master designs. Diagram how the viewer's eye moves through the image.

SUPPLIES: Images of master works of art and design.

COMPOSE AND SHARE RESULTS

- Select 10 master works from the previous group activity.
- Print the master works or work on a computer.
- Using a red pencil or a digital tool, draw lines along the edges that lead the viewer's eye into and around the image.
- Critique the results in a small group. Compare diagrams for analysis of similar results. Explain how the line influences direction. Discuss ways in which the line affects the emotional content or communicates information to the viewer.

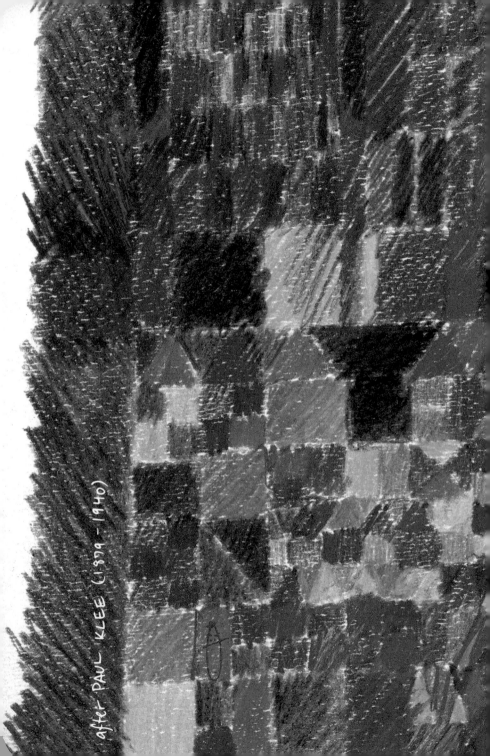

after PAUL KLEE (1879 - 1940)

GET IN SHAPE

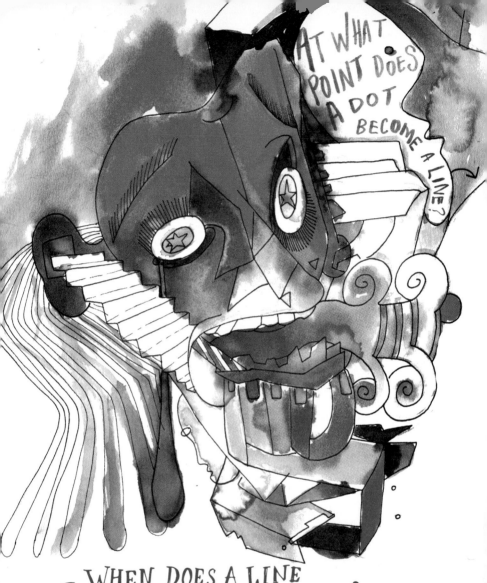

DOT, LINE, SHAPE, FORM— THERE
ARE NO PRECISE BOUNDARIES FOR
THESE TERMS.

WHEN ENGAGED IN DESIGN, RELAX
BOUNDARIES BECAUSE THERE ARE
NO ABSOLUTES.

- A **DOT** IS ALSO A **SHAPE**.
- A FEW **DOTS** IN A ROW ARE A **LINE**.
· ·
- A DASH IS A TINY LINE. —
- FOUR LINES OF EQUAL LENGTH,
 INTERSECTING AT RIGHT ANGLES
 CREATE A SQUARE. □

- A **SQUARE** IS A SHAPE.
- A **SQUARE** IS A PIXEL.
- A **CUBE** IS A SQUARE THAT'S
 ALSO A FORM. ⬓
- AN ELONGATED RECTANGULAR SHAPE
 MAY ALSO BE A LINE. ▬
- A **CIRCLE** IS A SHAPE. ○
- A **CIRCLE** IS A CONTINUOUS LINE.
- AN **ARC** IS THE PATH

OF A LINE AS WELL AS A SHAPE.
... UNLESS IT'S MADE OF STONE
 THEN IT BECOMES A FORM—
 AN ARCH.

STUART DAVIS (1892 - 1964)

design beyond dot & line

A **SHAPE** IS A DEFINED AREA OR FIGURE ON A FLAT, TWO-DIMENSIONAL SURFACE (PAPER, CANVAS, SCREEN, ETC.)

NOTE:

TRADITIONALLY, THE TERM FOR A TWO-DIMENSIONAL SURFACE IS **PICTURE PLANE**. IT'S AN IMAGINARY OR ILLUSIONARY DEPTH OF SPACE PERPENDICULAR TO THE VIEWER'S LINE OF VISION. MORE ON THE PICTURE PLANE LATER.

USE LINE SEGMENTS, **COLOR**, and/or TEXTURE. TO DEMARCATE **SHAPE**, MEASURED BY

HEIGHT and WIDTH.

LINES

LINE SEGMENTS

COLOR

TEXTURE

OPEN SHAPES

ARE OUTLINES OR CONTOURS THAT ARE PURPOSEFULLY LEFT INCOMPLETE.

CLOSED SHAPES

ARE COMPLETE OUTLINES OR CONTOURS.

POSITIVE AND NEGATIVE SHAPES

NOTED: SHAPE IS A DEFINED AREA ON A 2-D SURFACE,
AS WELL AS AN ACTUAL OBJECT IN 3-D.

GEOMETRIC OR ORGANIC, THE OBJECT IS THE POSITIVE SHAPE. THE
AREAS AROUND OR BETWEEN POSITIVE SHAPES ARE "NEGATIVE"—
IMPLIED. THE POSITIVE SHAPES CREATE THE NEGATIVE:
A DOUGHNUT'S HOLE IS A NEGATIVE SHAPE.
THE DOUGHNUT IS POSITIVE.
THE DOUGHNUT IS THE FOCUS OF ATTENTION, BUT THE
HOLE IS STILL IMPORTANT. WITHOUT THE HOLE, NO DOUGHNUT!

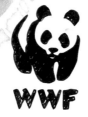

 NEGATIVE SHAPE

IMPLIED LINE +
POS./NEG. SHAPE

POSITIVE/NEGATIVE SHAPES

LOGOS: LANDOR ASSOCIATES (1994) LANDOR ASSOCIATES (1986) SEAN SERIO (2005)

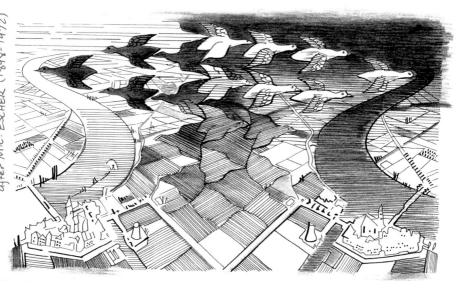

after M.C. ESCHER (1898-1972)

M.C. ESCHER, RENOWNED MASTER OF SHAPE REVERSALS— EYE-DECEIVING INTERPLAY
BETWEEN POSITIVE AND NEGATIVE SHAPES. WHICH ARE POSITIVE? WHICH ARE NEGATIVE?

A **FORM** IS A

SHAPE WITH PERCEIVED OR ACTUAL VOLUME.

MAX FRIEDMAN (1943—)

USE ← → **WIDTH**,
↕ **HEIGHT**,
AND **DEPTH**,
TO DEFINE FORM

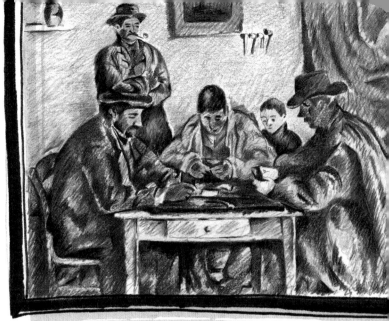

after PAUL CÉZANNE, (1839-1906)

BY USING PERSPECTIVE
AND/OR SHADING IN
DRAWING, TWO-DIMENSIONAL
SHAPES CAN APPEAR TO
HAVE **VOLUME**.

ACTUAL
FORMS
ARE FUNDAMENTAL
TO THREE-DIMENSIONAL
ART AND DESIGN.

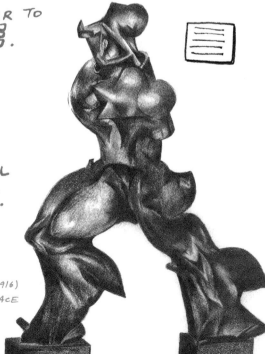

after UMBERTO BOCCIONI (1882-1916)
UNIQUE FORMS OF CONTINUITY IN SPACE

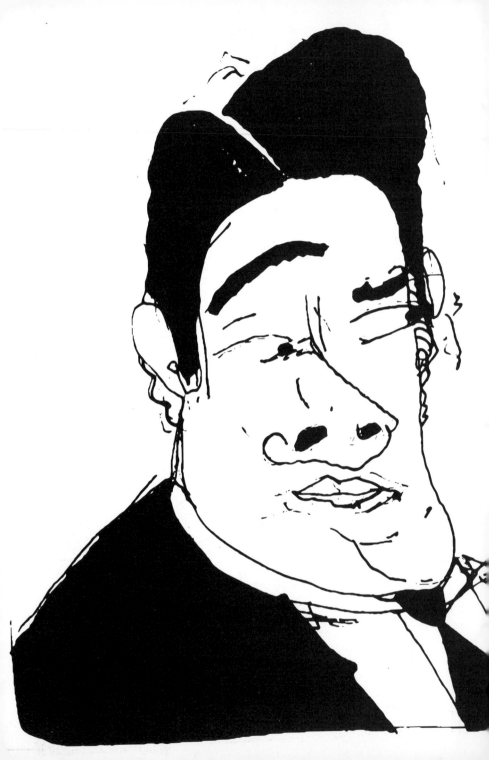

SHAPES ARE OF A TYPE

Side Note:

ESTABLISHED IN BASIC GEOMETRY, THE NAMES AND CATEGORIZED TYPES OF SHAPES (POLYGONS) AND FORMS (POLYHEDRONS) ESTABLISH ORDER AND GUIDANCE FOR DESIGN PURPOSES.

GEOMETRY IS A BRANCH OF MATHEMATICS WITH A FOCUS ON SHAPE, SIZE, RELATIVE POSITION, AND THE PROPERTIES OF SPACE. DESIGN HAS SIMILAR CONCERNS BUT THE FOCUS IS ARTFUL APPLICATION RATHER THAN MATHEMATICAL.

SHAPES COME IN TWO DISTINCT TYPES

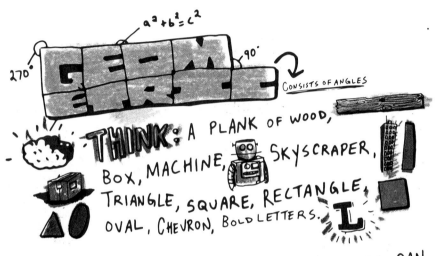

$a^2 + b^2 = c^2$

270°

90°

GEOMETRIC

CONSISTS OF ANGLES

THINK: A PLANK OF WOOD, BOX, MACHINE, SKYSCRAPER, TRIANGLE, SQUARE, RECTANGLE, OVAL, CHEVRON, BOLD LETTERS.

L

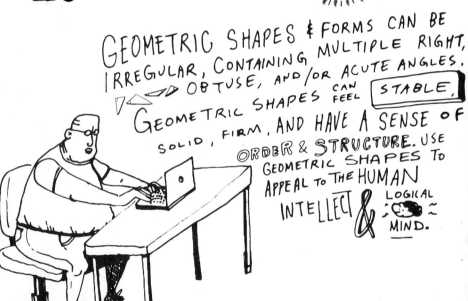

GEOMETRIC SHAPES & FORMS CAN BE IRREGULAR, CONTAINING MULTIPLE RIGHT, OBTUSE, AND/OR ACUTE ANGLES. GEOMETRIC SHAPES CAN FEEL STABLE, SOLID, FIRM, AND HAVE A SENSE OF ORDER & STRUCTURE. USE GEOMETRIC SHAPES TO APPEAL TO THE HUMAN INTELLECT & LOGICAL MIND.

ORGANIC

SHAPES LACK DEFINED ANGLES AND STRUCTURE.
THINK: BLOB OF DOUGH, SWIRL, PUDDLE, CURLICUE, BUBBLE, AMOEBA, LEAF, TREE, BOOMERANG, AND SCRIPT LETTERS.

ORGANIC SHAPES FEEL NATURAL. THE NATURALNESS SUGGESTS A SENSE OF RANDOMNESS, CREATIVITY, AND PLAY. USE ORGANIC SHAPES TO ACTIVATE HUMAN EMOTIONS AND APPEAL TO THE HEART.

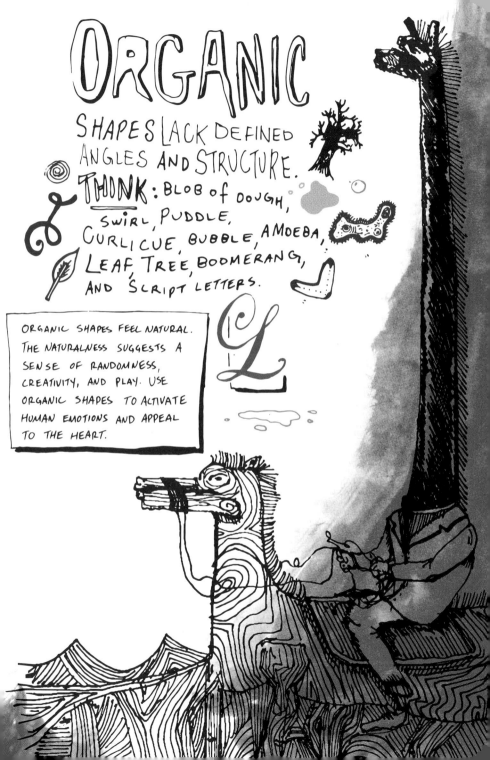

FORMAL SOLIDS

START

FORMS ARE ALSO ORGANIC AND GEOMETRIC. ORGANIC FORMS, SUCH AS A TREE, CAN BE RENDERED AS A FLAT SHAPE OR MORE FULLY REPRESENTED THROUGH THE ILLUSION OF VOLUME. A FLAT AND SIMPLIFIED SHAPE OF A TREE TENDS TO BE SYMBOLIC OF

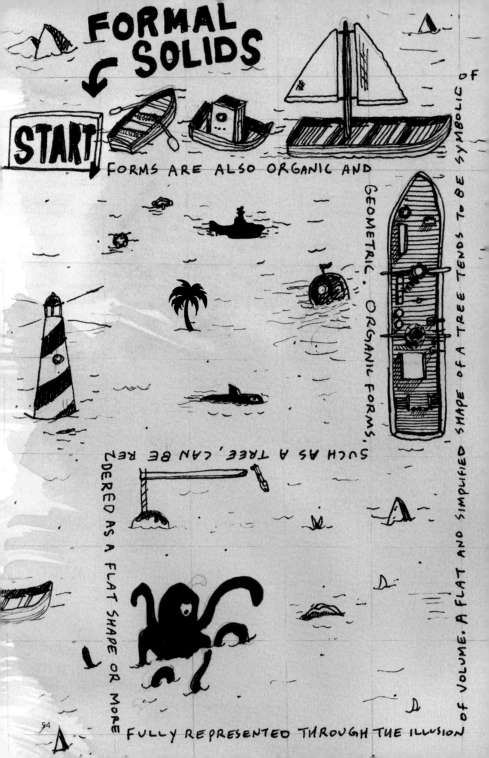

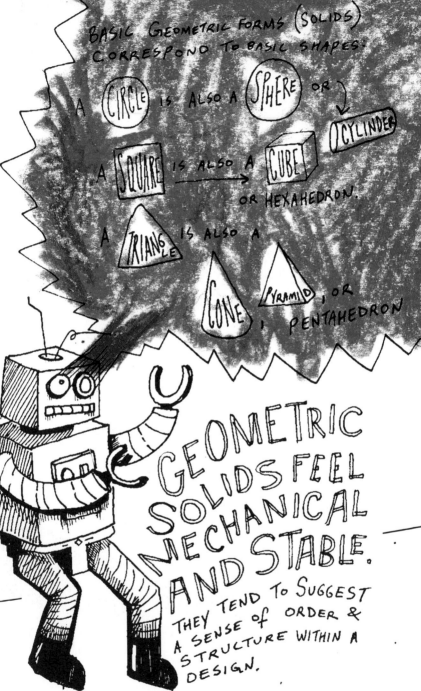

BASIC GEOMETRIC FORMS (SOLIDS) CORRESPOND TO BASIC SHAPES:

A CIRCLE IS ALSO A SPHERE OR CYLINDER

A SQUARE IS ALSO A CUBE OR HEXAHEDRON.

A TRIANGLE IS ALSO A CONE PYRAMID, OR PENTAHEDRON

GEOMETRIC SOLIDS FEEL MECHANICAL AND STABLE. THEY TEND TO SUGGEST A SENSE OF ORDER & STRUCTURE WITHIN A DESIGN.

FORMS & SHAPES

ARE OBJECTS, OR NOT.

SHAPES AND FORMS CAN BE ACTUAL
OBJECTS SUCH AS A GOAT, GUITAR,
OR A GIRL _ad infinitum_. OR, THEY
CAN JUST BE STRAIGHT-UP,
"NON-OBJECTIVE," GEOMETRIC SHAPES:

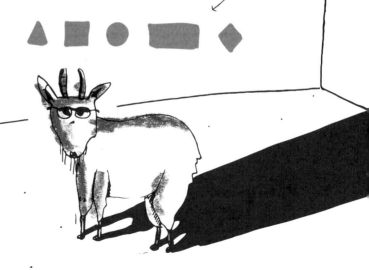

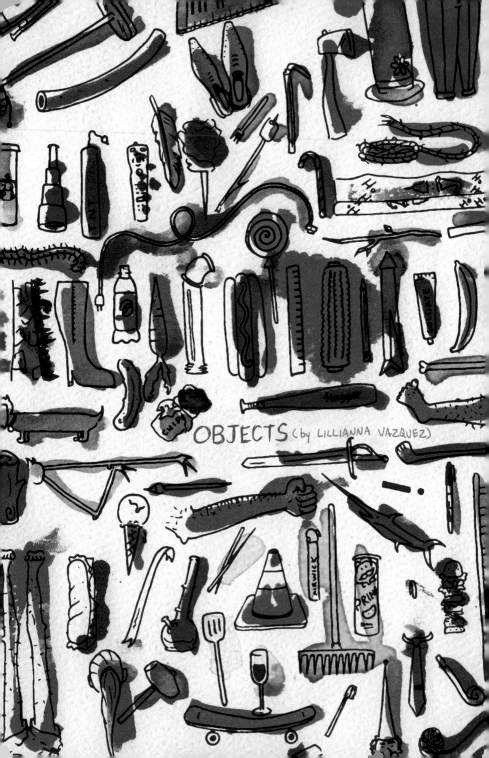

OBJECTS (by LILLIANNA VAZQUEZ)

EVERY OBJECT EITHER REPRESENTS ITSELF -OR- Serves as A SYMBOL of SOMETHING else.

PINEAPPLE "HOSPITALITY"

NOT OBJECTS

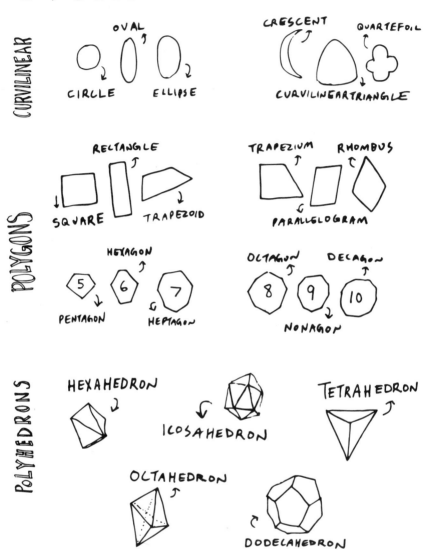

CURVILINEAR

OVAL

CIRCLE · ELLIPSE

CRESCENT · QUARTEFOIL

CURVILINEAR TRIANGLE

POLYGONS

RECTANGLE

SQUARE · TRAPEZOID

TRAPEZIUM · RHOMBUS

PARALLELOGRAM

HEXAGON

5 PENTAGON · 6 · 7 HEPTAGON

OCTAGON · DECAGON

8 · 9 NONAGON · 10

POLYHEDRONS

HEXAHEDRON · ICOSAHEDRON · TETRAHEDRON

OCTAHEDRON · DODECAHEDRON

IF A GEOMETRIC SHAPE OR FORM DOESN'T REPRESENT AN ACTUAL OBJECT, IT'S USED IN THE ABSTRACT TO SYMBOLIZE AN IDEA. BUT NOT ALWAYS.

after IKKO TANAKA
NIHON BUYO POSTER 1981

after SAUL BASS
THE MAN WITH THE
GOLDEN ARM 1955

after PAUL RAND
CUSTOMER SUPPORT CENTER 1980

after BRADBURY THOMPSON
THE ART of GRAPHIC DESIGN 1988

SOMETIMES DESIGNERS USE NON-OBJECTIVE SHAPES JUST BECAUSE THEY LOOK COOL.

SHAPES FUNCTION.

▲ SHAPES AND FORMS SUGGEST OBJECTS.

- SHAPES AND FORMS FUNCTION PHYSICALLY AS OBJECTS.

- SHAPES AND FORMS REPRESENT OBJECTS.

- SHAPES AND FORMS SYMBOLIZE THOUGHTS, EMOTIONS, & IDEAS.

REPRESENTATIONAL DENOTATION

THE <u>OUTLINE</u> OF A PIPE OR A FLOWER IS A SHAPE THAT REPRESENTS THE OBJECT ITSELF.

Ceci n'est pas une pipe.

THE <u>CONTOUR</u> OF A PIPE OR A FLOWER IS ALSO A SHAPE, BUT IT HAS FURTHER DESCRIPTIVE DETAIL, BEYOND AN OUTLINE.

homage to RENÉ MAGRITTE (1898-1967)

FILL THE OUTLINE WITH COLOR OR TEXTURE TO FURTHER DEFINE THE SHAPE & EXTEND THE SENSATION AND ILLUSION of REALITY.

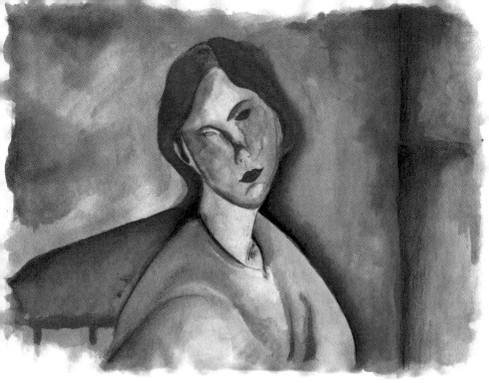

after AMEDEO MODIGLIANI (1884 - 1920)

REPRESENTATIONAL CONNOTATION

MAKING THE REPRESENTATION OF A
PIPE OR FLOWER ABSTRACT— THROUGH
DISTORTION, FRAGMENTATION, AN UNNATURAL
TEXTURE, OR ANY NUMBER OF STYLIZATIONS—
ALSO ALTERS THE WAY THE VIEWER PERCEIVES
AND INTERPRETS THE OBJECT.

ALSO, MANY REPRESENTATIONAL SHAPES HAVE AN ESTABLISHED SYMBOLIC MEANING RELATIVE TO THE CULTURAL CONTEXT.

for instance, IN THE U.S:

APPLE = EDUCATION

TREE = HERITAGE OR GROWTH

CLOCK = AGING

LIGHT BULB = A THOUGHT / IDEA.

NOTE:
: SEMIOTICS IS THE STUDY OF SIGNS AND SYMBOLS. THE FOCUS IS ON THE STUDY OF HOW MEANING IS CREATED, NOT THE DEFINITION ITSELF.

NOTE:
A VISUAL CLICHÉ IS A SYMBOL THAT HAS LOST ITS FEELING OF ORIGINALITY & EFFECTIVENESS BECAUSE OF OVERUSE.

SEARCHING for MEANING

THE SAME SHAPE CAN MEAN DIFFERENT THINGS TO DIFFERENT PEOPLE, DEPENDING ON THE PERSON'S CULTURAL AND SOCIAL EXPERIENCES. IF YOU COME ACROSS AN UNRECOGNIZABLE SHAPE, IT'S HUMAN NATURE TO ASSIGN IT A MEANING OR EMOTION.

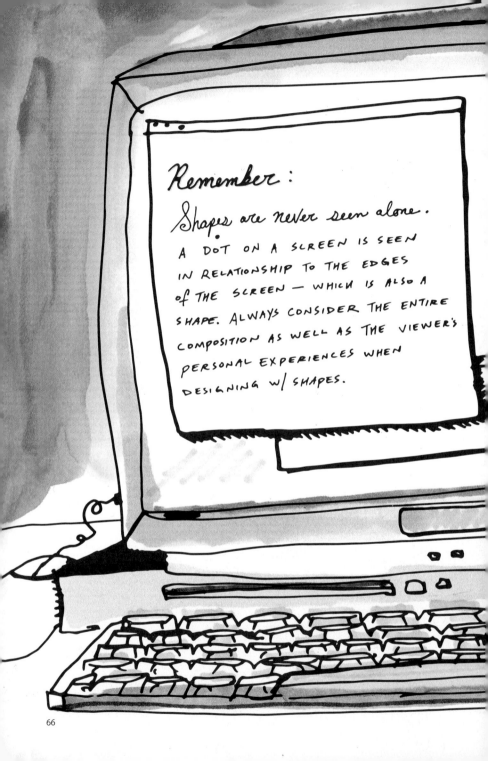

Remember:
Shapes are never seen alone.
A DOT ON A SCREEN IS SEEN
IN RELATIONSHIP TO THE EDGES
of THE SCREEN — WHICH IS ALSO A
SHAPE. ALWAYS CONSIDER THE ENTIRE
COMPOSITION AS WELL AS THE VIEWER'S
PERSONAL EXPERIENCES WHEN
DESIGNING w/ SHAPES.

CHEMIST
LINUS PAULING (1901-1994)

SAID THE BEST WAY
TO HAVE A GOOD IDEA
IS TO HAVE A LOT OF
IDEAS

STUDIES OF VISUAL PERCEPTION

CIRCLES ARE SHAPES.
LETTERS ARE SHAPES. BUT THE
HUMAN BRAIN DOES NOT TREAT
THEM EQUALLY. STUDIES SHOW
THAT THE BRAIN REACTS TO &
REMEMBERS SIMPLE SHAPES FIRST,
THEN COLORS, THEN WORDS,
WHICH REQUIRE MORE
TIME TO INTERPRET THAN
EITHER SHAPES OR
COLORS.

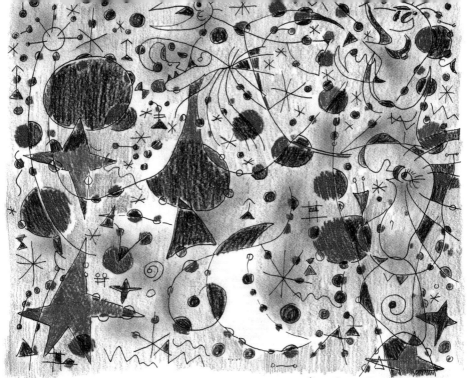

after JOAN MIRÓ (1893-1983)

Artists USE ABSTRACT & NON-OBJECTIVE SHAPES TO ELICIT EMOTIONS OR IDEAS, AND TO PURPOSELY LEAVE MUCH OF THE INTERPRETATION TO THE VIEWER IN ORDER TO ENGAGE THEM.

THEIR PURSUIT OF AN ORIGINAL STYLE OF SHAPE DISTINGUISHES THEIR IMAGES, IDEAS, & VISUAL "VOICE."

GRAPHIC DESIGNERS EMPLOY NON-OBJECTIVE SHAPES FOR LOGOS— DOTS, LINES, SHAPES, OR SPECIALIZED LETTERS THAT VISUALLY DISTILL AND REPRESENT A BRAND IDENTITY. NON-OBJECTIVE LOGOS ALLOW FOR BROAD INTERPRETATION OF SHAPE RATHER THAN LIMITING THE MEANING AS WOULD BE SEEN W/ PICTORIAL LOGOS.

LOGOS:
HSBC: HENRY STEINER (1983)
NIKE: CAROLYN DAVIDSON (1971)
PEPSI: ARNELL GROUP (2008)
WOOLMARK: FRANCESCO SAROGLIA (1964)

SUMMARY

There are no absolutes in determining or defining the visual elements— dot, line, shape, and form— but these elements affect the composition and concept of a design nonetheless.

Flat or volumetric, geometric or organic, shapes and forms can speak softly or carry a big bold stick— they can shout, or whisper, bully, or soothe. Shapes can be dynamic or still. Shapes communicate! Shapes represent themselves or, abstracted, they act as a symbolic visual language. They can represent a designer's grandly intellectual thoughts or they can simply be fun.

Be aware. Stay in shape.

...AND APROPOS OF NOTHING, SOME MUTANT NINJA SHAPES FOR YOU. COWABUNGA.

EXERCISES
& PROJECTS

1. SHAPE RECOGNITION

INDIVIDUAL ACTIVITY

A. SHAPES IN THE ENVIRONMENT: Search and record distinct shapes found in natural and built environments. Find one shape for each of the examples in the two basic categories: geometric and organic.

SUPPLIES: A digital camera and a computer with graphics software.

COMPOSE AND SHARE RESULTS

- Scout both natural and built environments for shapes. Shapes can be naturally occurring objects or created with paint or other means.
- Photograph the shapes. Select as many as needed to exemplify the types found in each category.
- Save the categorized shapes in a digital file.
- Share results with the class. Note the variety. Shapes are infinite.

GROUP ACTIVITY

B. ARTFUL SHAPES: Practice creating representational shapes. Choose a theme such as domestic objects.

SUPPLIES: A variety of traditional image-making tools such as markers, paint, and brushes; paper in a large roll.

COMPOSE AND SHARE RESULTS

- Organize in teams of three to five.
- Roll out the paper on a 10-foot area of floor space (or longer if possible).
- Using many different media, but only the color black, fill the paper with representational shapes. Draw from memory or from life. There should be both size and visual variety within the group.
- Share results for group comments.

2. PROVOCATIVE SHAPE AND FORM

INDIVIDUAL ACTIVITY

A. FORMAL ASSOCIATIONS: Search and record forms found in natural and built environments that are similar, such as a cloth mitten and a sassafras leaf or a seashell and a human ear.

SUPPLIES: Digital camera, computer, graphics software.

COMPOSE AND SHARE RESULTS

- Scout both natural and built environments for shapes or forms that are similar in structure.
- Photograph the forms. Select 8–10 pairs.
- Save the results in a digital file.
- Share results with the class and discuss how and why you paired the different forms.

B. ROLE REVERSAL: Search for either shapes or forms in the natural or built environment that represent something other then itself, such as a doorknob that looks like a human face.

SUPPLIES: Digital camera, computer, graphics software.

COMPOSE AND SHARE RESULTS

- Scout both natural and built environments for complex or simple forms.
- Photograph the forms. Find five examples of forms that provoke associations to an object other than itself.
- Save the results in a digital file.
- Share results with the class and discuss how and why you paired the different forms.

3. FORM IN APPLICATION

GROUP ACTIVITY

A. THE FORM OF A PRODUCT: Design a teapot.

SUPPLIES: Pencils, pens, markers, color pencils, and Bristol drawing paper; access to the Internet for research purposes only.

COMPOSE AND SHARE RESULTS

- This exercise is a competition; organize into teams of three to five.
- Design a teapot for one of the following audiences:
 - *The Jetsons*, an American animated sitcom produced by Hanna-Barbera from 1962–1963, 1985–1987.
 - Hipsters from Brooklyn, New York in 2014.
 - Japanese street fashionistas from the Harajuku district of Tokyo. (Search Google images for "FRUiTS").
- Each team has exactly three hours to research their design and create thumbnail sketches as well as three finished drawings showing two points of view: profile and three-quarter view. Include drawings of details.
- Present results formally without critique. State how the design visualizes the concept and why it is appropriate for the audience.
- External judges determine which group came up with the best solution based on which design is most appropriate to the audience and most original in concept.

after FRANK LLOYD WRIGHT (1867–1959)

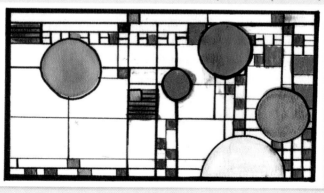

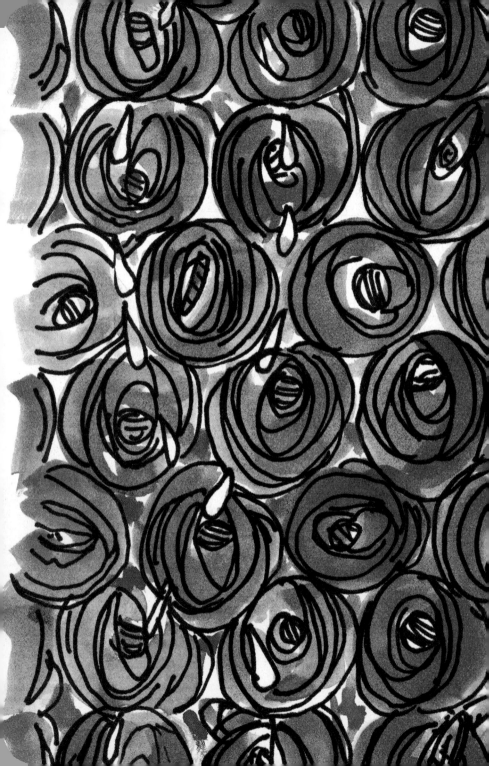

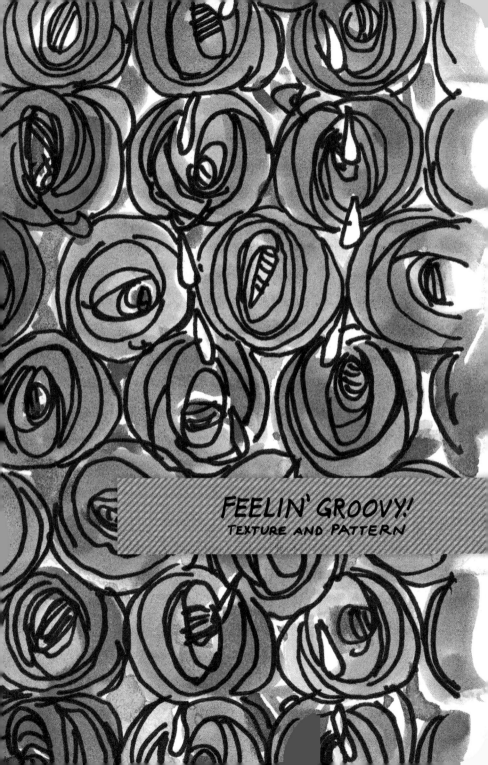

FEELIN' GROOVY!

TEXTURE AND PATTERN

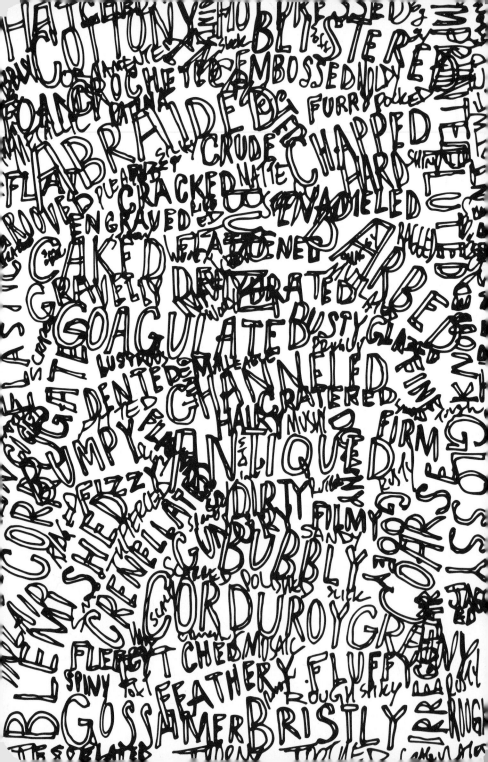

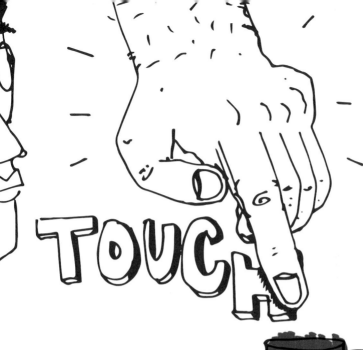

TOUCH IT

REAL OR SIMULATED.

[TEXTURE] IS THE ACTIVE SURFACE QUALITY OF A DOT, LINE, SHAPE, OR FORM. THE SURFACE IS ACTIVE BECAUSE OUR EYES RAPIDLY SCAN UP, DOWN, OVER, ACROSS, AND AROUND THE TEXTURE TO GET A VISUAL FEEL FOR IT.

EYE SCAN OF A FACE

OPENING SPREAD:
after CHARLES RENNIE MACKINTOSH
(1868-1928) ROSE AND TEAR DROP

TACTILE MEMORIES

SMOOTH AND ELEGANT OR PEACEFUL LIKE WATER, **HARSH** AND **PRICKLY,** OR SLEEK AND SLICK, *earthy* OR ETHEREAL, TEXTURES SUGGEST EMOTIONS AND IDEAS.

EACH OF US RESPONDS TO TEXTURE BASED ON OUR OWN STRONG MEMORIES & ASSOCIATIONS.

FURBALL: SCARY OR ADORABLE?

Textures can be
visually metaphorical
or poetic too. ___

CONSIDER THIS METAPHOR:

LOVE IS A ROSE.

AND PERHAPS THIS POEM:

A ROSE IS A ROSE IS A ROSE IS
MARVELOUSLY SOFT & WICKEDLY THORNY.

SIMPLY, TEXTURE

DIFFERENTIATES DOT FROM DOT, LINE FROM _LINE_, AND BETWEEN SHAPES, DOTS, AND _LINES_.

> ## Side Note:
> DESIGNING WITH TEXTURE ENGAGES THE VIEWER AND CREATES A SENSE OF PHYSICAL CONNECTION TO THE OTHERWISE FLAT REMOTE FEELING OF A SCREEN.

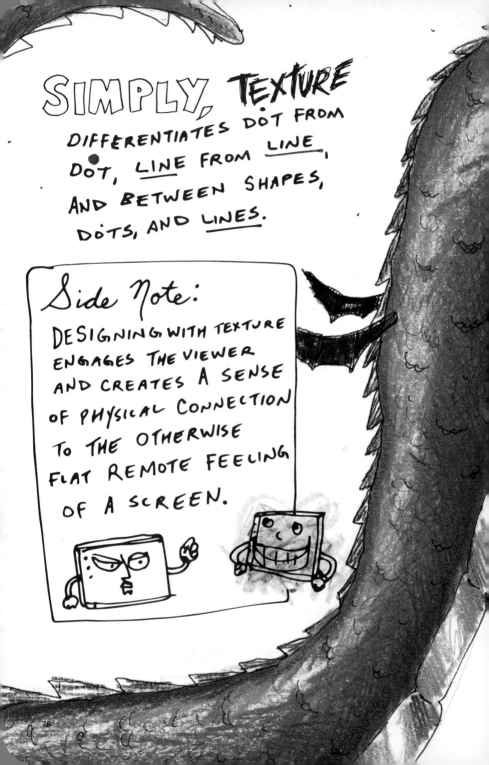

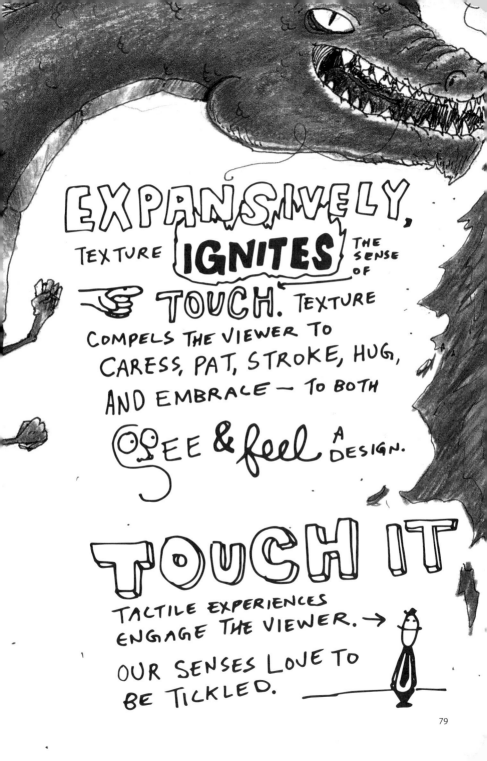

EXPANSIVELY, TEXTURE **IGNITES** THE SENSE OF TOUCH. TEXTURE COMPELS THE VIEWER TO CARESS, PAT, STROKE, HUG, AND EMBRACE — TO BOTH SEE & feel A DESIGN.

TOUCH IT

TACTILE EXPERIENCES ENGAGE THE VIEWER. →

OUR SENSES LOVE TO BE TICKLED.

Engaging AND TOUCH SENSORY EX DESIGN. ADD CRACKED, *gooey*, ORNAMENTED, RIDGED, VELVETY, ELEMENT AND SEE WHAT—

→both sight
SWELLS THE
PERIENCE of A
A BLISTERED, FUZZY,
ENCRUSTED,
Lustrous,
PLEATED,
TESSELLATED,
WOOLY
TO A DESIGN
(FEEL)
HAPPENS.

ORGANIC

TEXTURES FEEL AND LOOK RANDOM, WHICH MAKES A DESIGN FEEL LIFE-LIKE.

Apply an ORGANIC BRICK OR STONE TEXTURE TO A DRAWING OF A CUBE & THE CUBE WILL APPEAR DENSE & HEAVY.

AFTER MILTON GLASER (1929–)

THE TEXTURE ENHANCES THE REALITY OF THE ILLUSION.

DRAW FEATHERS W/ A BRUSH AND A SOFT LINE QUALITY TO MAKE THEM "FEEL" REAL.

TEXTURE

MAKES OBJECTS SEEM MORE LIFE-LIKE AND IMBUE THEM WITH INHERENT MEANING

 ← STONE CUBE =
MECHANICAL STABLE, SOLID, STRONG.

← DOWNY FEATHER =
NATURAL SOFT, GENTLE, UNRESTRAINED.

GEOMETRIC

TEXTURES HAVE A RECOGNIZABLE, SYSTEMIC ORDER, OR STRUCTURE.

THE STRUCTURE AND ORDERED REPETITION OF SHAPES CREATES A SPECIFIC TYPE OF TEXTURE

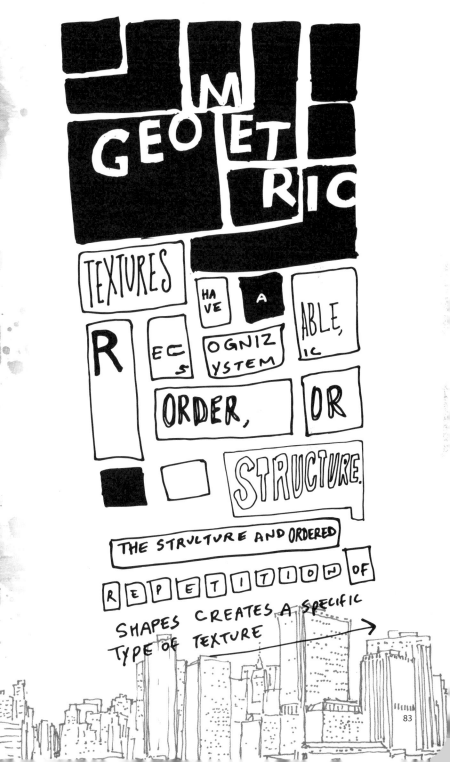

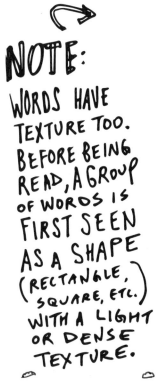

NOTE:

WORDS HAVE TEXTURE TOO. BEFORE BEING READ, A GROUP OF WORDS IS FIRST SEEN AS A SHAPE (RECTANGLE, SQUARE, ETC.) WITH A LIGHT OR DENSE TEXTURE.

FLAT OR WARPED:
DESIGNING WITH
DENSITIES

IN DESIGNING WITH TEXTURES OR
PATTERNS, USE THEM LOOSELY AND
KEEP IT SIMPLE OR MAKE THEM
TIGHT & DENSE.

A PATTERN'S DENSITY DETERMINES ITS
RELATIVE LIGHTNESS OR DARKNESS.

AT TIMES, DENSE TEXTURE ASSUMES THE
CHARACTER OF A PATTERN DUE TO THE
OVERALL CONTINUITY.

A HIGH CONTRAST OF LIGHT AND DARK
DENSITY OF DOTS OR LINES CREATES
THE ILLUSION OF DIMENSIONALITY AND/OR
VOLUME AND CAN HELP BRING AN OBJECT
TO LIFE.

BOTH REPETITION AND CONTINUITY MAKE
PATTERNS APPEAR FLAT —UNTIL WARPED
WHICH CAUSES THE PATTERNS TO TAKE ON
THE ILLUSION OF VOLUME AND MAKES THEM
APPEAR TO HAVE DIMENSION.

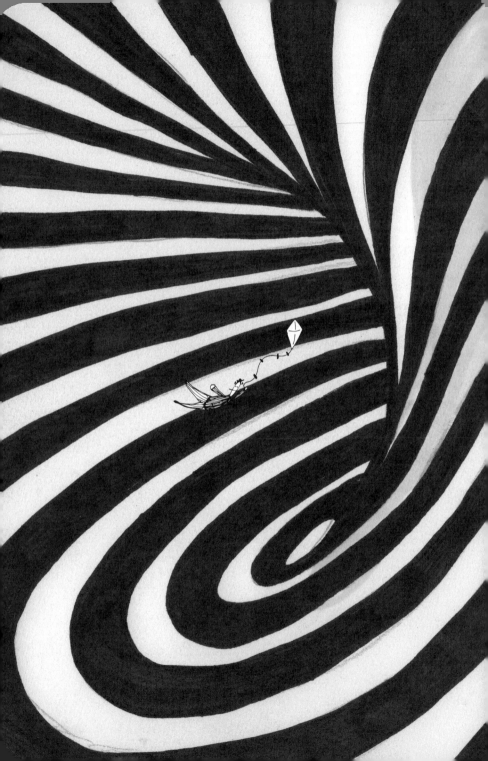

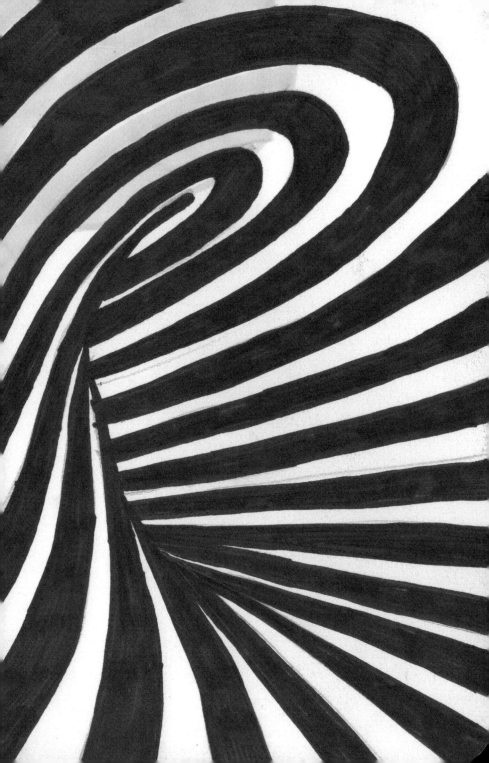

BENOÎT
MANDELBROT
(1924-2010)

" A 'Rough' World "
From the notebook of Hayley Gruenspan

Nature has many design secrets. A fractal used to be one of them. Mathematician Benoît Mandelbrot coined the term "fractals" to describe a mathematical structure and extended the concept to describe patterns in nature.

From the mysterious twirling Romanesco broccoli to spiraling seashells, fractals are everywhere.

Identify a fractal by its never-ending irregular, repeating shapes. An organic pattern!

Classic geometrical shapes are regular with a collection of points that have a definite measure. Fractals are more irregular or rough.

The fundamental unit of a fractal is a pattern. A pattern structure establishes a fractal (roughness) beyond the geometrical dimensions.

This is why fractals are hard to measure precisely. Fractals are not just theoretical constructs, but a part of nature.

Fractals can also be found in many types of art, with great examples in African art.

Fractals are most familiar to people as computer generated graphics and were once popular as screen savers.

Math, nature, and art all have fractals in common. Mandelbrot thought of himself as a mathematician who did not play with formulas, but played with pictures.

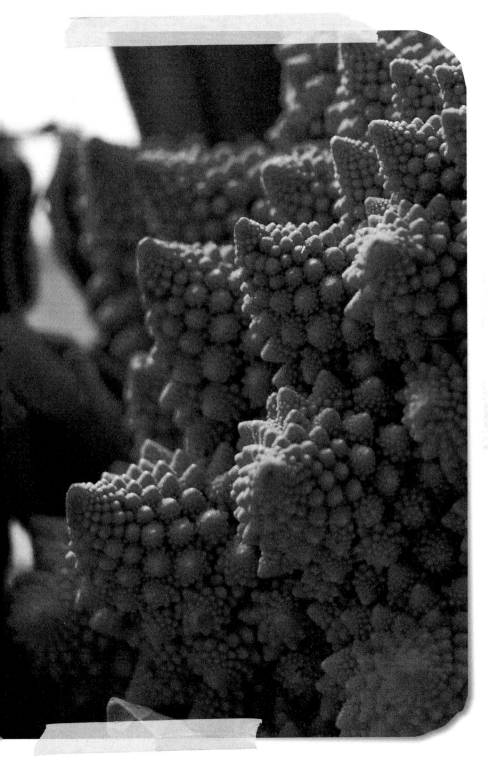

REAL! TEXTURE

FOR 3D Design, including Sculpture, Architecture, Built Environments, Textiles, Packaging, and the vast range of industrial products — from baby bottles & cars to potato peelers and Xerox machines — consideration of texture is not optional; it's essential. Slippery smooth, or rough hewn, 3D objects always have texture.

PAYING ATTENTION TO THE MATERIALS AND SURFACES OF PRODUCTS YOU USE EVERY DAY MAKES YOU A BETTER PRODUCT DESIGNER.

PEPPERIDGE FARM PACKAGING

Milano

UTENSILS BY OXO

Design Note:
ENVISION: POLISHED STEEL, RUSTY IRON, BRICK, GRANITE, WOOD, FEATHERS, ENAMEL PAINT, SOAP, BUBBLES, CACTUS, LACE, PEBBLES ON A BEACH, OXFORD CLOTH, MUD, LINEN PAPER, MASHED POTATOES, ETC.

TEXTURAL RELIEF FOR 2D

TWO DIMENSIONAL ART AND DESIGN CAN USE ACTUAL TEXTURES TO RAISE THE SURFACE, ACTIVATE THE SENSE OF TOUCH, & HEIGHTEN THE OVERALL Sensory EXPERIENCE

VISUAL Relief from FLATNESS

SOME OF THESE TECHNIQUES AND MATERIALS INCLUDE:

• **SPECIALTY PRINTING** • **PAPER** • **COLLAGE**

PRINTED design

RELIES ON <u>TEXTURE</u> & <u>PATTERN</u>
FOR ADDED DIMENSIONALITY $\overset{\land}{\circ}$ PHYSICALITY.

SPECIALTY PRINTING

TECHNIQUES CREATE ACTUAL TEXTURES.

SCAVENGER HUNT! FIND EXAMPLES OF SPECIALTY PRINTING TECHNIQUES AND PASTE THEM HERE.

- DIE-CUT

- LASER CUT

- SPOT VARNISH

- FOIL STAMPING

- EMBOSSING

- DEBOSSING

- THERMOGRAPHY

- ENGRAVING

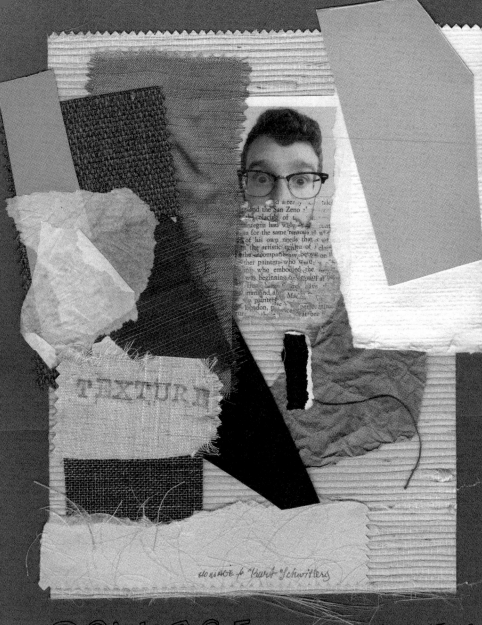

COLLAGE — THE ARRANGEMENT OR ASSEMBLAGE OF ACTUAL TEXTURES: BITS AND PIECES OF PRINTED MATTER, FABRICS, METAL, WIRE, PAPER, CARDBOARD, ETC. A COLLAGE IS MEANT TO BE PHYSICAL AND INSPIRE A VISCERAL RESPONSE FROM THE VIEWER.

PRINT-BASED DESIGN
USING THICK PAINT +
COLLAGE FOR A
TACTILE SENSATION.

NOTE:
LOTS OF WEBSITES USE
COLLAGE TO GIVE THE
FLAT SCREEN AT LEAST
AN ILLUSION OF DIMENSION
AND TEXTURE. TOUCH ADDS
A PERSONAL FEELING THAT
IS LACKING IN SCREEN-BASED
ART AND DESIGN.

HARD WERKEN NO. 1, 1979

PAPER Substrates

HAVE TEXTURES AND/OR
PATTERNS THAT ARE WOVEN,
SLEEK, ROUGH, GLOSSY, PEBBLY,
STRIPED, EMBOSSED, CHECKERED,
CRINKLED, ETC.

BUT YOU CAN PRINT ON MORE THAN
JUST PAPER INCLUDING FABRIC, VINYL,
LEATHER, WOOD, AND METAL — EACH
HAS ITS OWN CHARACTERISTIC TEXTURE.

TEXTURAL ALTERATIONS

IN SCULPTURE, ARCHITECTURE, AND 3D DESIGN, THE ELEMENT OF TEXTURE IS AN ACTUAL, PHYSICAL THING. BUILDINGS AND SCULPTURES ARE MADE OF SLICK GLASS OR ROUGH STONE, WOOD, OR STEEL — OFTEN THERE ARE MANY TEXTURES COMBINED FOR FUNCTIONAL AND AESTHETIC EFFECTS.

WHEN PAINTED, BURNT, SCRATCHED, OR POLISHED, THE NATURAL TEXTURE OF THE MATERIALS TRANSFORMS INTO SOMETHING OTHER THAN ITSELF.

MANIPULATING TEXTURE CHANGES THE CHARACTER, EXPRESSIVENESS, AND MEANING OF AN OBJECT OR DESIGN.

TEXTURES EXPAND OUR VISUAL VOCABULARY.

after CONSTANTIN BRÂNCUȘI (1876–1957) BIRD IN SPACE (POLISHED BRONZE)

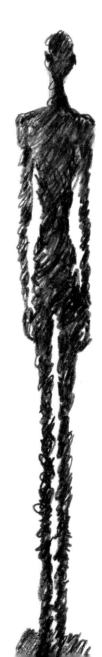

after EDGAR DEGAS (1834-1917) (BRONZE, TULLE, & SILK)

after ALBERTO GIACOMETTI (1901-1966) GREAT STANDING WOMAN III (BRONZE)

PLAYING WITH MEANING

A CUBE ▢ (GEOMETRIC FORM) MADE OF FEATHERS ✒
(ORGANIC FORM) CARRIES A CONTRADICTION IN ITS INHERENT
MEANING. A ✒ FEATHER DRAWN WITH THE TEXTURE
OF POLISHED ⬜ BRONZE ALTERS THE REALITY
OF THE FEATHER.

SWAPPING THE REALITY OF TEXTURES ALSO
EXPANDS THE VISUAL VOCABULARY OF SHAPE AND
FORM BY CREATING A VISUAL OXYMORON.

> **NOTE:** MÉRET OPPENHEIM'S WORK
> ENTITLED OBJECT (FUR-COVERED CUP,
> SAUCER, AND SPOON) WAS CREATED FOR
> A SURREALIST EXHIBITION OF OBJECTS.

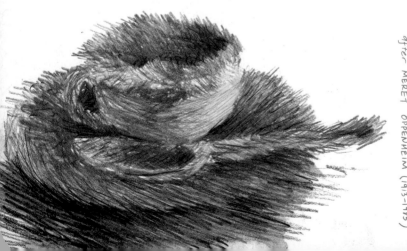

after MÉRET OPPENHEIM (1913-1985)

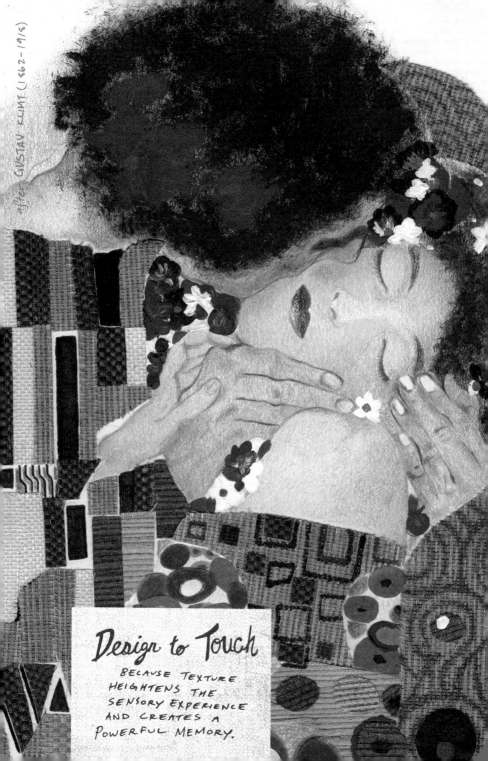

after GUSTAV KLIMT (1862–1918)

Design to Touch

BECAUSE TEXTURE
HEIGHTENS THE
SENSORY EXPERIENCE
AND CREATES A
POWERFUL MEMORY.

SUMMARY

The most touchy feely of all the design elements, texture forces the other elements to get physical. Texture activates the surface of dots, lines, and shapes, ignites our sense of touch, makes the unreal seem real, gives objects a sense of meaning, and can even make you feel happy, sad, confused, excited, or afraid. Whether randomly organic or a geometric pattern, textures make your designs stand out.

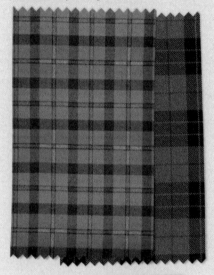

"I AM CHRISTOPHER MACLEOD OF THE CLAN MACLEOD!"

EXERCISES
& PROJECTS

1. IDENTIFYING PATTERN

INDIVIDUAL ACTIVITY

A. A PATTERN THROUGH TIME: Pattern, like the other elements, can be used to identify a person or group, a place, or even a brand. Historically, complex plaid patterns known as tartans represented specific regions, families, or clans in Scotland. These tartans signify heritage and are a source of ethnic and national pride.

SUPPLIES: Colored pencils or pens, computer with graphics software.

COMPOSE AND SHARE RESULTS

- Research the history of Scottish tartans and how they're designed and created— and why.
- Use visual elements such as color and line and shape to represent yourself, your family, or a group to which you belong. Consider what colors represent the person, family, or group. What kinds of lines and/or shapes work together with the colors to make the complex pattern unique?
- Create a tartan using the chosen visual elements. This can be created by hand with colored pens and pencils or digitally on a computer.
- Photograph or scan the compositions and save in a digital file.

Share results with the class. How is your tartan similar or different from everyone else's? Be able to discuss how and why yours represents you or your family or group.

2. VISUAL OXYMORON

INDIVIDUAL ACTIVITY

A. CONTRADICTING TEXTURES: A texture, whether represented two- or three-dimensionally, carries with it a specific feel or connotation. Pairing opposites against each other results in a visual surprise. Create a visual oxymoron— an incongruous or seemingly self-contradictory composition.

SUPPLIES: Any imaging media such as paint, pencils, ink, crayon, etc., plus any number of three-dimensional objects that have specific texture(s).

COMPOSE AND SHARE RESULTS

- Pick two objects that are opposites or represent an oxymoron (see Oppenheim's *Object*— a teacup, saucer, and spoon, covered in fur— in this chapter). Consider an object that has a "slippery" connotation, like a banana, wrapped in grippy tape.

- If working two-dimensionally, visualize (draw, paint, collage, etc.) the object covered with the oxymoronic texture. If working three-dimensionally, cover, wrap, or otherwise envelop the object in the textural substrate. Be sure not to lose the form (and therefore the identity) of the original object, or the effect will be ruined.

- Photograph or scan the compositions and save in a digital file.

- Share the archive with the class on Pinterest or in a group digital file system.

3. ORGANICALLY GROWN PATTERN

INDIVIDUAL ACTIVITY

A. ZENTANGLE: Zentangles are images of repetitive patterns that grow spontaneously and without "rules". Growing the pattern focuses creativity and is meant to be relaxing.

SUPPLIES: Black felt-tipped marker. Smooth Bristol board. A quiet room.

COMPOSE AND SHARE RESULTS

- There are no requirements or rules for a Zentangle but the process is not doodling. Be deliberate.

- The resulting image can be a non-objective organic or geometric multi-unit pattern. Suggestion: 8" x 10" board.

- Start in one corner of the board with a simple unit such as triangle with a swirl within it.

- Repeat the unit and allow it to grow geometrically or organically outward in any direction and change as your thoughts flow.

- The point of a Zentangle is to focus on the design process so that external distractions fade away.

- There is no end. Keep tangling.

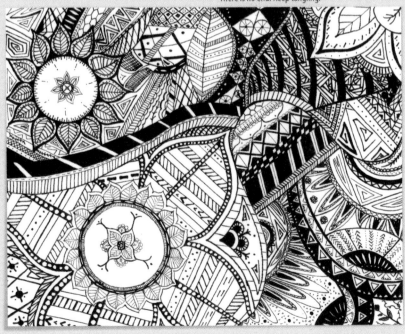

WITH GREAT COLOR COMES GREAT RESPONSIBILITY

COLOR is → FICKLE, PREDICTABLE, SERIOUS, PLAYFUL, WILDLY, EMOTIONALLY COMPLEX AND DEFIES

↗ SILLY, SOBER, RICH, DULL, RAPTUROUS, DREADFUL, FRIGHTENING, PRECISE CATEGORIZATION. → YET CATEGORIZATION (AND STILL)

COLOR is, SENSATIONALLY STIMULATING,

HEART-WARMING, SEXY, SWEET, SENSATIONALLY STIMULATING, COLOR.

BRILLIANT, MORBID, TROPICAL, STULTIFYING, COLD, ↙ ESTABLISHES A FOUNDATION FOR DESIGNING WITH

after HENRI MATISSE (1869 - 1954) GREEN STRIPE (MADAME MATISSE)

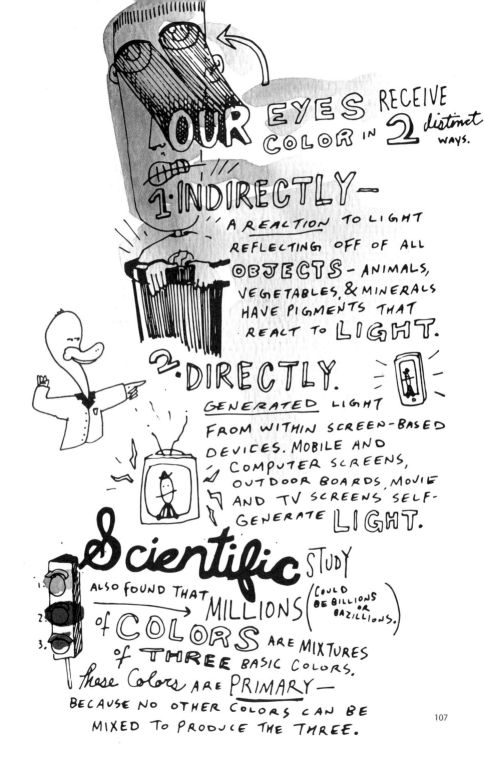

OUR EYES RECEIVE COLOR IN 2 distinct WAYS.

1. INDIRECTLY —

A REACTION TO LIGHT REFLECTING OFF OF ALL OBJECTS — ANIMALS, VEGETABLES, & MINERALS HAVE PIGMENTS THAT REACT TO LIGHT.

2. DIRECTLY.

GENERATED LIGHT FROM WITHIN SCREEN-BASED DEVICES. MOBILE AND COMPUTER SCREENS, OUTDOOR BOARDS, MOVIE AND TV SCREENS SELF-GENERATE LIGHT.

Scientific STUDY ALSO FOUND THAT MILLIONS (COULD BE BILLIONS OR BAZILLIONS.) of COLORS ARE MIXTURES of THREE BASIC COLORS. These Colors ARE PRIMARY — BECAUSE NO OTHER COLORS CAN BE MIXED TO PRODUCE THE THREE.

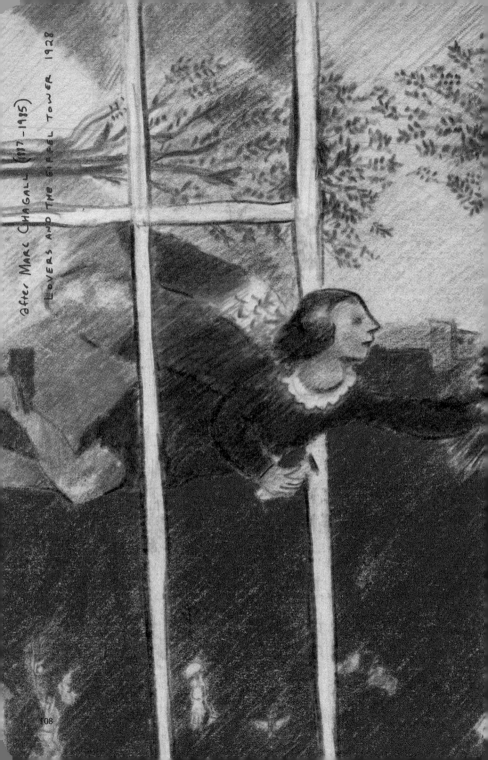

After Marc Chagall (1917-1985)

Lovers and the Eiffel Tower 1928

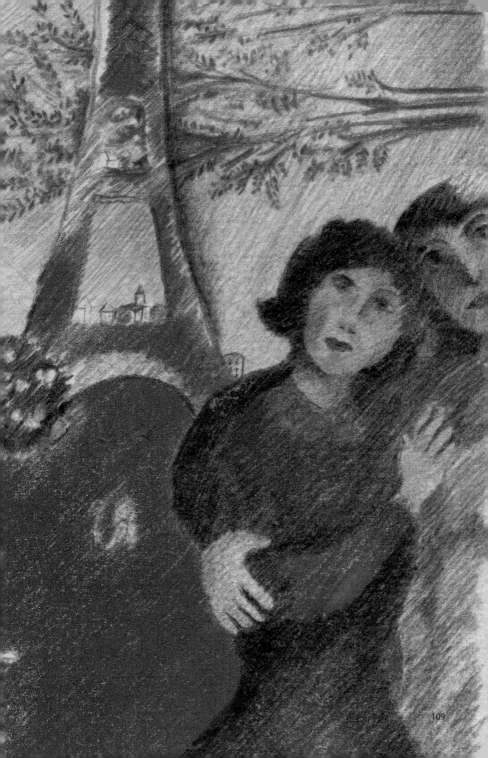

 RGB:

RED, GREEN, & BLUE ARE THE PRIMARY COLORS OF DIRECT LIGHT, KNOWN AS **ADDITIVE COLOR** BECAUSE ADDING ALL OF THE COLORS TOGETHER = <u>WHITE.</u>

 RYB:

RED, YELLOW, & BLUE ARE THE PRIMARY COLORS OF INDIRECT LIGHT, KNOWN AS **SUBTRACTIVE COLOR** BECAUSE SUBTRACTING ALL OF THE LIGHT = <u>BLACK.</u>

MIXING PAIRS OF THE <u>PRIMARY COLORS</u> RESULTS IN <u>SECONDARY COLORS.</u>

R + G = YELLOW LIGHT

R + B = MAGENTA LIGHT

R + G = CYAN LIGHT

R + B = VIOLET

R + Y = ORANGE

Y + B = GREEN

MIXING A PRIMARY (BLUE) & A SECONDARY COLOR (ORANGE) RESULTS IN A TERTIARY COLOR, WHICH FEELS & ACTS NEUTRAL.

COLOR PROPERTIES

WHETHER SELF-ILLUMINATED OR A REACTION TO AN OBJECT, EACH COLOR ALSO HAS **THREE** PROPERTIES TO CONSIDER:

HUE

— THE COLOR ITSELF, AS IN RED, GREEN, BLUE, ETC.

SATURATION

— DEPTH OF HUE FROM RICH TO DULL.

& BRIGHTNESS

— RELATIVE LIGHTNESS AND DARKNESS OF THE HUE.

(TINTS & SHADES)

SIDENOTE:

PLACE WARM COLORS AMONG COOL TO MAKE THEM POP OUT.

(COOL COLORS ARE SHY IN COMPARISON.)

DON'T FORGET! COLOR TEMPERATURE:

RED, ORANGE, AND YELLOW ARE WARM.

BLUE, GREEN, & VIOLET ARE COOL.

UNDERSTAND HOW COLOR WORKS TO MAKE BETTER DESIGN CHOICES.

PHYSICAL RELATIONSHIPS:

Like dots, lines, shapes, forms, and patterns, color is a design element, but it doesn't stand alone. In art and design, colors are always seen in relationship — interacting. Find color combinations that work together in harmony to sullessfully communicate an emotion or idea.

IN HARMONY:

Any search for harmonious color relationships starts with ye olde colour wheel, which comes to us courtesy of...

TRIAD 1: 3 hues that form an equilateral triangle. 1 primary, 2 secondaries. Intermediate colors are mixtures of one primary and one secondary.

TRIAD 2: 3 hues that form an isosceles triangle. Split complement: one hue plus the two hues adjacent to its complement.

TETRAD: 2 pairs of complements that form a square, rectangle, or trapezoid.

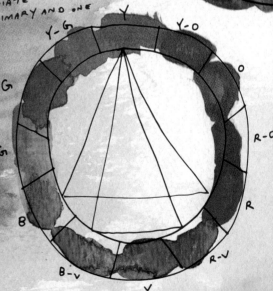

DIAD: TWO HUES IN BALANCED OPPOSITION ARE KNOWN AS COMPLEMENTS. THESE ARE THE COLOR PAIRS OF SUCCESSIVE CONTRAST E.G. RED/GREEN.

ANALOGOUS: THREE OR MORE HUES ADJACENT TO ONE ANOTHER. THEIR PROXIMITY IS UNIFYING.

POLYGONS: THREE PAIRS OF COMPLEMENTS SUCH AS A HEXAGON.

Y-O

O

R-O

R

R-V

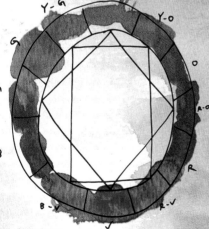

Y-G Y
G Y-O
 O
-G R-O
 R
B R-V
B-V V

...THE ENGLISH PHYSICIST AND MATHEMATICIAN SIR **ISAAC NEWTON** (1642-1727), WHO WAS THE FIRST TO DOCUMENT COLOR RELATIONSHIPS IN THE FORM OF A NEVER-ENDING CIRCLE. BUT THERE IS MORE THAN JUST <u>ONE</u> COLOR WHEEL. MANY, MANY, MANY EXIST, DEVELOPED BY ARTISTS, DESIGNERS, SCIENTISTS, PHILOSOPHERS, AND EDUCATORS IN AN EFFORT TO AID THE UNDERSTANDING OF COLOR RELATIONSHIPS FOR USE IN SCIENCE, ART, DESIGN, AND THE STARSHIP ENTERPRISE.

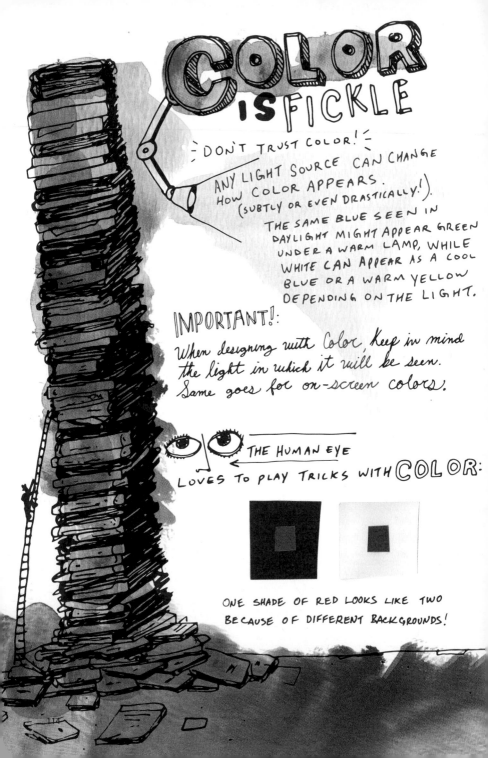

COLOR IS FICKLE

:- DON'T TRUST COLOR! -:

ANY LIGHT SOURCE CAN CHANGE HOW COLOR APPEARS. (SUBTLY OR EVEN DRASTICALLY!).

THE SAME BLUE SEEN IN DAYLIGHT MIGHT APPEAR GREEN UNDER A WARM LAMP, WHILE WHITE CAN APPEAR AS A COOL BLUE OR A WARM YELLOW DEPENDING ON THE LIGHT.

IMPORTANT!:

When designing with Color, keep in mind the light in which it will be seen. Same goes for on-screen colors.

THE HUMAN EYE
LOVES TO PLAY TRICKS WITH COLOR:

ONE SHADE OF RED LOOKS LIKE TWO BECAUSE OF DIFFERENT BACKGROUNDS!

COLOR INTERACTION:

A SHAPE WITH A PALE HUE
APPEARS TO EXPAND WHEN
SURROUNDED BY A DARK COLOR,
BUT A DARK SHAPE APPEARS TO CONTRACT
WHEN SURROUNDED BY A PALE HUE.

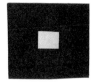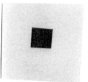

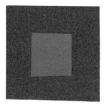

A NEUTRAL GRAY SURROUNDED BY
A STRONG HUE WILL MAKE THE GRAY
FEEL LIKE THE HUE'S COMPLEMENT.

ONE HUE PLACED ON
COMPLEMENTARY COLOR
BACKGROUNDS WILL
APPEAR TO HAVE DIFFERENT
LEVELS OF BRIGHTNESS.

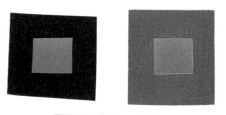

TEST!

MAKE ONE HUE/SHADE APPEAR
TO BE TWO DIFFERENT SHADES
BY SURROUNDING IT WITH LIGHT
AND DARK VERSIONS OF THE
SAME HUE.

PLACE TWO SLIGHTLY DIFFERENT
(MID) VALUES OF THE SAME HUE
ON CONTRASTING COLOR FIELDS
TO MAKE THEM APPEAR TO
BE THE SAME (VALUE).

MAKING YOUR DESIGNS KULER:

BEYOND THE COLOR WHEEL, FIND COLOR SCHEMES - A.K.A. COLOR PALETTES - IN NATURE, ART, CITY STREETS, CAVES, SOCKS, EVERYWHERE!

ADOBE **KULER** © IS A MOBILE OR WEB APP THAT CAPTURES THE HUE, SATURATION, AND BRIGHTNESS OF A SCENE OR IMAGE. INSTANT PALETTE. BUT IT'S ALSO "KUL" TO JUST FIND COLORS WHILE DRIVING WITH THE TUNES BLASTING. OH YEAH!

EMOTIONAL AND CULTURAL
RELATIONSHIPS

COLORS CAN CONJURE DEEP FEELINGS DEPENDING ON INDIVIDUAL AND CULTURAL EXPERIENCES.

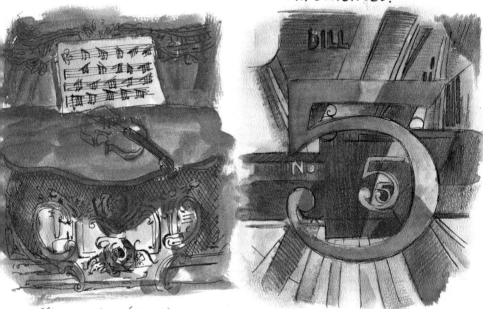

after RAOUL DUFY (1877-1953)
THE YELLOW CONSOLE WITH A VIOLIN 1949

after CHARLES DEMUTH (1883-1935)
I SAW THE FIGURE 5 IN GOLD 1928

DESCRIPTIVE ADJECTIVES & OTHER NAMING CONVENTIONS FOR COLOR ARE HELPFUL IN UNDERSTANDING CULTURAL CONTEXT, SYMBOLISM, & EMOTIONAL RESPONSE.

Think:
SEA GREEN, ROYAL PURPLE, PURE WHITE, CANDY APPLE RED, FIRE ENGINE RED, MOODY BLUE, SUNNY YELLOW, TROPICAL ORANGE, TICKLED PINK, CURIOUS YELLOW, GREEN WITH ENVY

EMOTIONS AND SYMBOLISM ASSOCIATED w/
COLORS ARE COMPLEX; COLOR CAN HOLD
MANY MEANINGS. **BLACK**, FOR EXAMPLE,
CAN CONJURE FEELINGS OF POWER,
FORMALITY, SENSUALITY, DEATH,
ELEGANCE, OR EVEN

HYPNOTISM,
DEPENDING
ON WHO'S
LOOKING
AT IT
AND THE
CONTEXT
IN WHICH
IT'S USED.

EACH PERSON SEES AND RESPONDS TO
COLOR THROUGH THE FILTER OF HIS
OR HER OWN CULTURAL BACKGROUND
AND EXPERIENCES. FOR EXAMPLE,
THE COLOR WHITE INDICATES PURITY
& INNOCENCE IN THE UNITED STATES,
BUT IT'S A SYMBOL OF MOURNING
AND ENLIGHTENMENT IN INDIA.

"REMEMBER IT'S NOT ALL ABOUT YOU (OR ME);
IT'S ABOUT THE AUDIENCE! DO THE RESEARCH
WHEN DESIGNING WITH COLOR!"

SUMMARY

What's your favorite color? Everyone has one. People take color personally. And that's something to keep in mind when designing. Color is a powerful design element, but you must understand how to mix it, match it, and manage it to get the results you want from it. Everyone sees color through their own personal and cultural filters, which means any one color can mean different things to different people. But that doesn't mean you can't use color to achieve specific results. Here are a few guidelines to follow when designing with color:

1. Select colors with purpose and intent.

2. Simplify. Fewer colors are easiest to remember.

3. Look to basic color wheel relationships for simple harmonies; add some neutrals as a rest area.

4. Light source affects color. And colors affect other colors. Consider the fluctuations and interactions.

5. Select colors with cultural context in mind and remember an individual's response too.

NOTE TO SELF:
LOTS MORE TO LEARN. NEED TO GRAB THAT COLOR THEORY NOTEBOOK FROM LAST SEMESTER, AND GET READY TO DESIGN!

EXERCISES
& PROJECTS

1. COLORFUL TEXTURES

INDIVIDUAL ACTIVITY

A. A TEXTURE & PATTERN OF LETTERS: Arrange letterforms into a pattern to explore contrasting color temperatures.

SUPPLIES: Pigmented ink stamp pads, letterform stamps, Bristol board.

COMPOSE AND SHARE RESULTS

- Use 11" x 17" vertical format.
- Create a single unit of a pattern using only two to four letterforms.
- Repeat (stamp) the unit across the entire surface using warm and cool colors.
- The result should be a "pulsing" effect created by contrast of color temperature.

2. COLOR PROPERTIES

INDIVIDUAL ACTIVITY

A. TINTS & SHADES: Explore the 3 major properties of color.

SUPPLIES: Gouache paint, Bristol board, brushes.

COMPOSE AND SHARE RESULTS

- Use 11" x 17" vertical format.
- Create an abstract pattern. Divide in half vertically.
- Paint the left half of the composition with full saturation colors. Paint the right half with tints and shades of corresponding hues.

...AND GO TO DESIGN-FUNDAMENTALS.COM AND CLICK "RESOURCES" FOR MORE EXERCISES.

SPACE... THE FINAL FRONTIER

DOT, LINE, SHAPE, FORM, TEXTURE, READY, SET, GO...

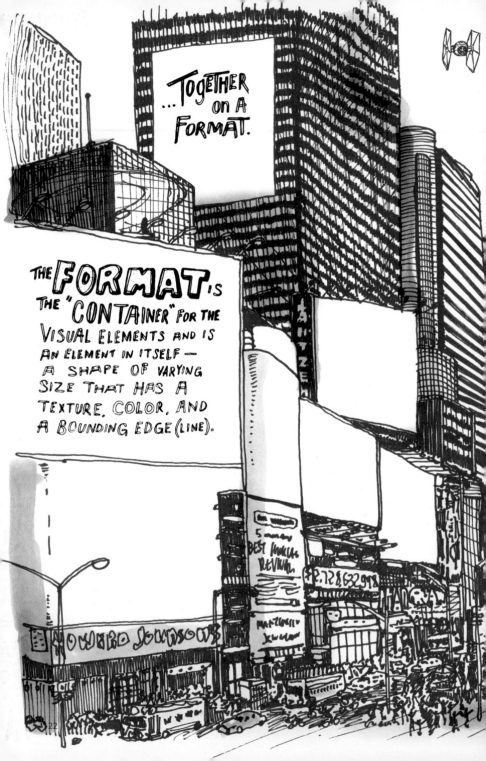

...TOGETHER on A FORMAT.

THE **FORMAT** IS THE "**CONTAINER**" FOR THE VISUAL ELEMENTS AND IS AN ELEMENT IN ITSELF — A SHAPE OF VARYING SIZE THAT HAS A TEXTURE, COLOR, AND A BOUNDING EDGE (LINE).

TO ⟩ACTIVATE⟨ THE ENTIRE CONTAINER (FORMAT), ARRANGE ELEMENTS TO CREATE →INTERACTION← WITH THE EDGES/MARGINS AND THE TOP, MIDDLE, AND BOTTOM AREAS.

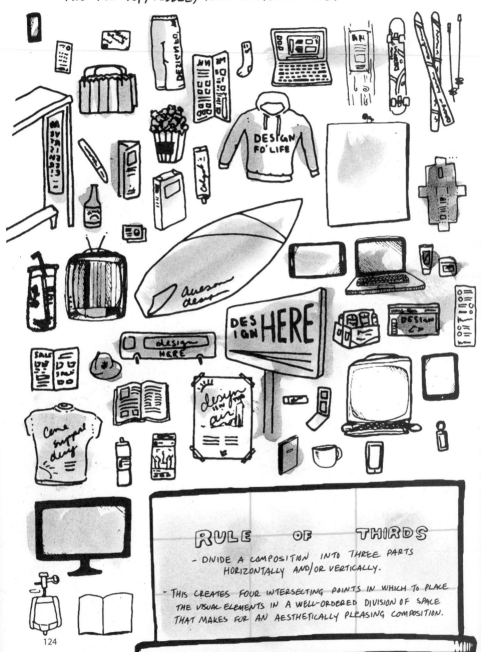

RULE OF THIRDS

- DIVIDE A COMPOSITION INTO THREE PARTS HORIZONTALLY AND/OR VERTICALLY.

- THIS CREATES FOUR INTERSECTING POINTS IN WHICH TO PLACE THE VISUAL ELEMENTS IN A WELL-ORDERED DIVISION OF SPACE THAT MAKES FOR AN AESTHETICALLY PLEASING COMPOSITION.

2D FORMATS CONTAIN PICTORIAL SPACE.

3D FORMATS OCCUPY PHYSICAL SPACE.

THINK ABOUT EDGES

- PLACE ELEMENTS WITHIN THE CONTAINER WITH CONSIDERATION TO THE CONTAINER'S EDGES.

- ELEMENTS PARALLEL TO THE EDGES FEEL STABLE.

- DIAGONALS FEEL DYNAMIC.

- EDGES ARE ACTIVE. DON'T FORGET THEM!

EQUESTRIAN STATUE OF MARCUS AURELIUS (176 A.D.) (13.9 FT. TALL)

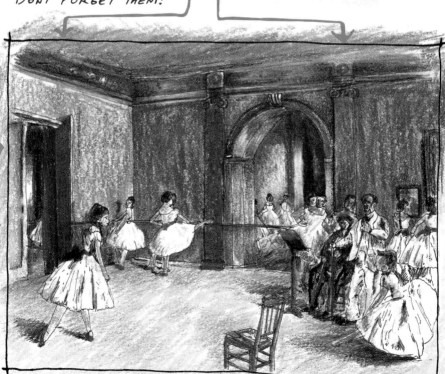

after EDGAR DEGAS (1834-1917)

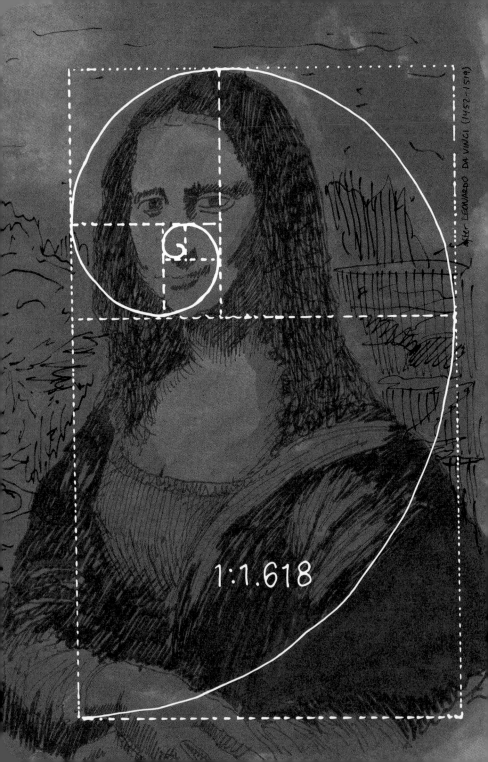

After LEONARDO DA VINCI (1452-1519)

1:1.618

SACRED GEOMETRY:

ANOTHER TRIED AND TRUE SYSTEM FOR PROPORTIONALLY DIVIDING A PAGE, SCREEN, OR ANY OTHER FORMAT.

THE GOLDEN RATIO IS A MATHEMATICAL PROPORTION THAT IS OFTEN FOUND IN NATURE (FLOWERS, SEASHELLS).

THIS GOLDEN RULE HAS GUIDED ARTISTS AND DESIGNERS FOR CENTURIES AND WAS THOUGHT TO BE DIVINE.

DA VINCI'S MONA LISA USED THE GOLDEN RECTANGLE (BASED ON THE GOLDEN RATIO) TO ACHIEVE BALANCE.

NOTE:
GOLDEN RATIO
EQUATION

$$\frac{a+b}{a} = \frac{a}{b} = \varphi$$

ANCIENT CULTURES OF EGYPT, GREECE, ROME, & INDIA EMPLOYED THE BALANCING PRINCIPLES OF SACRED GEOMETRY IN THEIR ART AND ARCHITECTURE.

GIVEN THAT ARTISTS AND DESIGNERS HAVE PURSUED PICTORIAL EQUILIBRIUM WITH THE HIGHEST REVERENCE SINCE MAN FIRST LEARNED HOW TO HOLD A BRUSH, MOLD CLAY, & BUILD TEMPLES, IT'S A USEFUL TOOL FOR CREATING AESTHETICALLY PLEASING COMPOSITIONS.

REALIZING SPACE

THE SPACE ON A 2D FORMAT IS AN ILLUSION, MEANT TO TRICK THE EYE IN ORDER TO HEIGHTEN A SENSE OF REALITY AND DRAW IN THE VIEWER.

SPACE WITHIN A GIVEN FORMAT IS KNOWN AS THE

PICTURE PLANE —

A TWO-DIMENSIONAL SURFACE, PERPENDICULAR TO THE VIEWER'S LINE OF VISION, ON WHICH TO ORGANIZE A DESIGN.

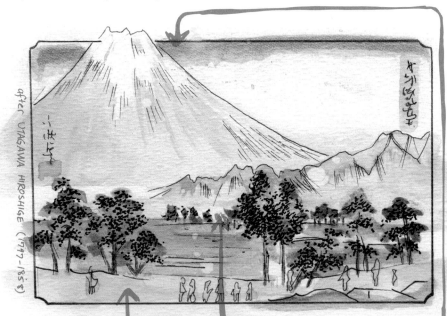

after UTAGAWA HIROSHIGE (1797-1858)

THE ILLUSIONARY DEPTH OF THE PICTURE PLANE IS GENERALLY DIVIDED INTO THREE PLANAR LEVELS: FOREGROUND, MIDDLEGROUND, BACKGROUND

— MANIPULATION OF THE ELEMENTS WITHIN THE PICTURE PLANE DETERMINES AND CONTROLS THE DEPTH.

FIGURE AND GROUND

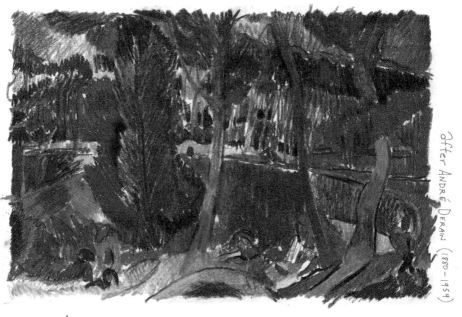

after André Derain (1880–1954)

WITHIN THE PICTURE PLANE, THINK of THE ELEMENTS AS EITHER THE "FIGURES," WHICH ARE THE OBJECTS, OR POSITIVE SHAPES, AND THE "GROUND," WHICH ARE THE NEGATIVE SHAPES, OR BACKGROUND.

CONSIDERATION OF FIGURE & GROUND SHAPES WITHIN THE COMPOSITION CREATES AN INTERRELATIONSHIP AND A COMPOSITION THAT FEELS WHOLE. THINK: GESTALT (AGAIN).

FIGURE/GROUND RELATIONSHIPS IN WHICH ROLES REVERSE TRICK THE VIEWER'S PERCEPTION — AND CREATE PLAYFUL INTERACTIONS.

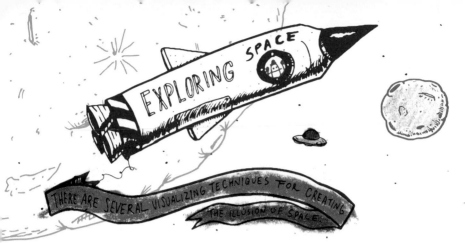

EXPLORING SPACE

THERE ARE SEVERAL VISUALIZING TECHNIQUES FOR CREATING THE ILLUSION OF SPACE.

OVERLAP: ONE ELEMENT APPEARS TO BE IN FRONT OF ANOTHER.

PLACEMENT: AN ELEMENT AT THE TOP OF THE FORMAT APPEARS TO BE IN THE DISTANCE.

SIZE & SCALE: LARGE ELEMENTS SEEM CLOSER THAN SMALL ELEMENTS. (MOST OF THE TIME)

LINEAR PERSPECTIVE: REPRESENTATION OF OBJECTS IN SPACE USING PARALLEL LINES THAT APPEAR TO VANISH ON AN IMAGINARY POINT ON A HORIZON LINE CORRESPONDING WITH THE VIEWER'S EYE LEVEL.

ATMOSPHERIC DEPTH: A SPECIAL ILLUSION IN WHICH DISTANT OBJECTS BECOME OUT OF FOCUS, LACK DETAIL, & APPEAR HAZY AND MUTED.

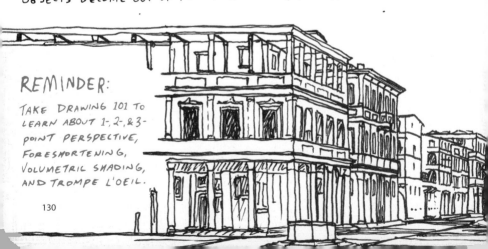

REMINDER:

TAKE DRAWING 101 TO LEARN ABOUT 1-, 2-, & 3- POINT PERSPECTIVE, FORESHORTENING, VOLUMETRIC SHADING, AND TROMPE L'OEIL.

SUMMARY

Dots, lines, shapes, textures, and colors don't exist in thin air. Visual elements need a container in which to be held. Containers have an overall shape—a format that reacts to the elements within it. That format has space—an illusion of depth that can be manipulated into multiple levels or planes. The elements or "figures" residing on the spatial planes can seem to push forward toward the viewer or recede onto the background plane. Whether the elements are figure or ground, the space deep or shallow, all is relative to the purpose of the design solution.

EXERCISES
& PROJECTS

1. HAZY SPACE

INDIVIDUAL ACTIVITY

A. A COLORFUL CLIMATE: Create an illusion of atmospheric depth on a flat surface.

SUPPLIES: Gouache paint, watercolor paper, and brushes.

COMPOSE AND SHARE RESULTS

- Divide a 12" square into 8-inch "pie" wedges.
- Divide each wedge into 12 segments.
- Fill each wedge with a gradation of values from dark / bright to light / dull color.
- Critique and determine the success of the result.

2. SPATIAL STORYTELLING

INDIVIDUAL ACTIVITY

A. TUNNEL BOOK: This illustated book format uses the foreground, middle, and background planes to tell a

OOPS! GOTTA GO TO DESIGN-FUNDAMENTALS.COM AND CLICK "RESOURCES" FOR THE REST OF THE EXERCISE. THIS ONE SOUNDS LIKE FUN!

ARRANGING THE ELEMENTS
IN SPACE WITHIN A
FORMAT REQUIRES
KNOWLEDGE OF THE...

PRINCIPLES OF COMPOSITION!

Onward to Hierarchy, Unity & Rhythm, and Balance!

VISUAL HIERARCHY!

IT'S GOOD TO BE THE KING

1, 2, 3...

- PRIORITIZE.
- CREATE A PLAN.
- LEAD THE WAY POINT TO POINT.
- ESTABLISH ORDER.

- The First Principle of Design -

VISUAL
HIERARCHY IS A RANKING

SYSTEM FOR ORGANIZING ELEMENTS IN A COMPOSITION
BASED ON THEIR ORDER OF IMPORTANCE.

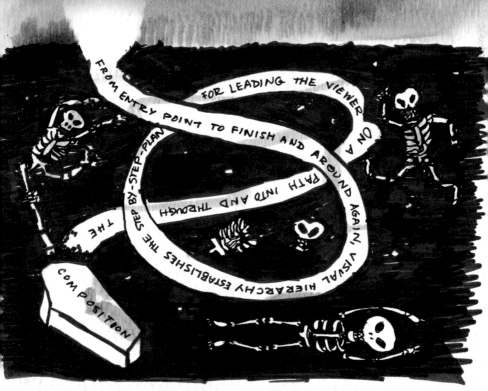

FROM ENTRY POINT TO FINISH AND AROUND AGAIN, VISUAL HIERARCHY ESTABLISHES THE STEP BY-STEP-PLAN FOR LEADING THE VIEWER ON A PATH INTO AND THROUGH THE COMPOSITION

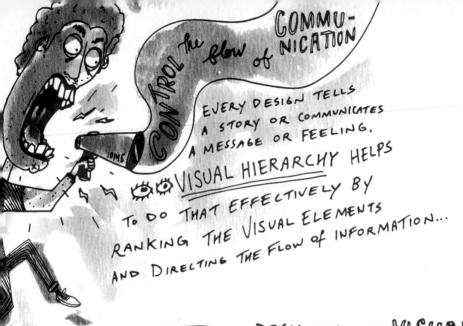

CONTROL the flow of COMMUNICATION

EVERY DESIGN TELLS A STORY OR COMMUNICATES A MESSAGE OR FEELING.

👀 VISUAL HIERARCHY HELPS TO DO THAT EFFECTIVELY BY RANKING THE VISUAL ELEMENTS AND DIRECTING THE FLOW OF INFORMATION...

DESIGNERS USE **VISUAL HIERARCHY** TO GUIDE THE EYE THROUGH A COMPOSITION SO VIEWERS DON'T GET LOST OR CONFUSED IN WHAT COULD EASILY BECOME A JUMBLE OF WORDS, LINES, SHAPES, IMAGES, COLORS, & TEXTURES.

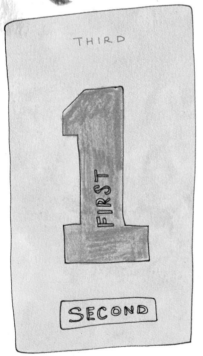

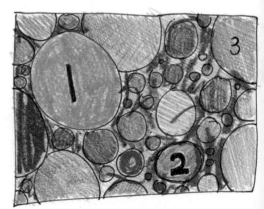

WHERE TO START?

Most viewers start @ the top of the composition and then travel downward, making the top a common entry point.

the singuois

Lynn Coady

after CHIP KIDD (1964 –)

Lolita

VLADIMIR NABOKOV

after JOHN GALL (1963 –)

BUT VIEWERS DONT ALWAYS HAVE TO START AT THE TOP & WORK THEIR WAY DOWN. THEY CAN COME IN ANYWHERE. IT'S UP TO THE DESIGNER, WHO CAN CREATE A VISUAL PATH FOR THE VIEWER THAT **STARTS**, STOPS, AND RESTARTS FROM ANY NUMBER OF POINTS IN A COMPOSITION.

Note:

HIERARCHICAL PURPOSE:
- CALL TO ATTENTION
- GUIDE
- HOLD ATTENTION

TO CREATE AN ENTRY POINT, EMPHASIZE ONE ELEMENT OR AREA OVER ALL THE OTHERS. DIMINISH EMPHASIS ON OTHER ELEMENTS TO CREATE THE "STEPPING STONES," OR POINTS, ON WHICH A VIEWER MOVES ALONG THE PATH. ONE WAY TO DO THIS IS BY USING **CONTRAST.**

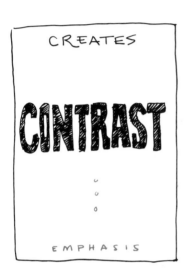

CREATES

CONTRAST

ᵕ
ᵕ
₀

E M P H A S I S

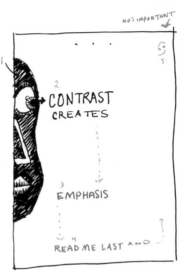

NOT IMPORTANT

CONTRAST
CREATES

EMPHASIS

READ ME LAST AND

CONTRAST EXISTS WHEN ONE ELEMENT IN A COMPOSITION IS DIFFERENT FROM ANOTHER ELEMENT. THE GREATER THE DIFFERENCE BETWEEN ELEMENTS, THE GREATER THE CONTRAST.

EYES LOVE **CONTRAST.**
THEY SEEK IT OUT. WHEN LOOKING AT A COMPOSITION, THE EYE GOES TO THE ELEMENT W/ THE MOST CONTRAST FIRST. DESIGNERS USE CONTRAST TO CREATE EMPHASIS & ESTABLISH A VISUAL PECKING ORDER FOR A COMPOSITION, GUIDING THE EYE FROM THE ELEMENTS WITH THE MOST CONTRAST DOWN TO THE ONES W/ LEAST CONTRAST.

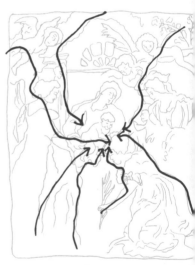

POINTING THE WAY TO THE CENTER OF ATTENTION

After Peter Paul Rubens (1577—1640)

THE
MOST CLEARLY
EMPHASIZED
ELEMENT OR
AREA OF THE
VISUAL HIERARCHY
IS THE

FOCAL POINT.

THE FOCAL POINT
IS USUALLY THE
ENTRY POINT TO
THE COMPOSITION

A COMPLICATED
COMPOSITION MAY
HAVE A PRIMARY
FOCAL POINT
FOLLOWED BY
SECONDARY
FOCAL POINTS TO
CREATE STARTING,
STOPPING, & RESUMING
POINTS AMID A
MULTITUDE OF ELEMENTS.

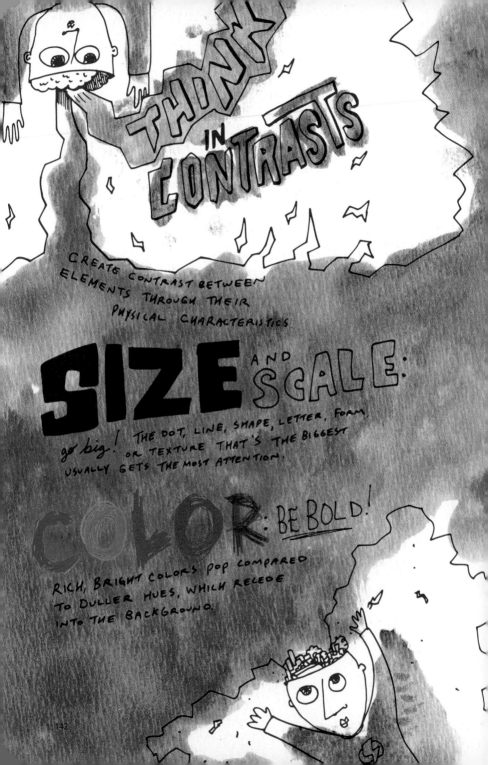

THINK IN CONTRASTS

CREATE CONTRAST BETWEEN ELEMENTS THROUGH THEIR PHYSICAL CHARACTERISTICS

SIZE AND SCALE:

go big! THE DOT, LINE, SHAPE, LETTER, FORM, OR TEXTURE THAT'S THE BIGGEST USUALLY GETS THE MOST ATTENTION.

COLOR: BE BOLD!

RICH, BRIGHT COLORS POP COMPARED TO DULLER HUES, WHICH RECEDE INTO THE BACKGROUND.

 : GET ROUGH!

HIGHLY TEXTURAL ELEMENTS STAND OUT MORE THAN SMOOTHER ONES.

LINE: *Lead the way!*

LINES — WHETHER REAL OR IMPLIED — CAN CREATE THE PATH THAT LITERALLY POINTS TO A PARTICULAR AREA OF THE DESIGN TO GIVE IT EMPHASIS.

THICK LINES DOMINATE T H I N.

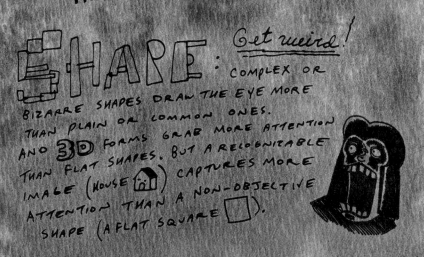

SHAPE: *Get weird!* COMPLEX OR BIZARRE SHAPES DRAW THE EYE MORE THAN PLAIN OR COMMON ONES. AND **3D** FORMS GRAB MORE ATTENTION THAN FLAT SHAPES. BUT A RECOGNIZABLE IMAGE (HOUSE 🏠) CAPTURES MORE ATTENTION THAN A NON-OBJECTIVE SHAPE (A FLAT SQUARE ☐).

DENSITY: *STRENGTH IN NUMBERS!*

AN AREA WITH MANY SMALL ELEMENTS DRAWS MORE ATTENTION THAN A SPARSELY POPULATED ONE.

143

THINK, PLACE, & POINT

- Create contrast w/ elements by placing them strategically:

0. DRAW IN THE VIEWER:

The top of the format is a traditional and natural starting point. To get started somewhere else, pump up the contrast of the focal point.

2. FRONT & CENTER:

Consider the placement of elements in the foreground plane — elements in the foreground tend to be seen first.

3. AIM FOR THE TARGET:

The middle or center of the format can command attention when all other elements rotate around or point toward the center.

ЯƎVƎЯƎ тнƎ ƆOИТЯAƧТ

IN A STRANGE (BUT TRUE) TWIST OF
DESIGN LOGIC, SMALL ELEMENTS, DULL
COLORS, & THIN LINES CAN ALSO BE
SEEN IN CONTRAST AND CREATE EMPHASIS.

PUT IT IN ● ISOLATION.

IN SOMETHING OF A CONTRAST TO THE "BIGGER
IS BETTER" RULE OF CREATING EMPHASIS & VISUAL
HIERARCHY, A SMALL ELEMENT CAN ALSO
ATTRACT ATTENTION — IF IT IS CLEARLY
ISOLATED FROM OTHER ELEMENTS OF A
COMPOSITION. ISOLATION DRAWS THE VIEWER'S
EYE TO THE SMALL ELEMENT.

FLASH YOUR BRIGHTS.

MAKE A SMALLER ELEMENT STAND OUT
BY USING A BRIGHT COLOR TO GAIN
ADVANTAGE OVER A LARGER ELEMENT
THAT IS DULL IN COLOR.

CHANGE ONE LITTLE THING.

IF AN ELEMENT IS REPEATED 99
TIMES IN A COMPOSITION (THINK: PATTERN),
BUT THE 100TH ELEMENT IS DIFFERENT IN
COLOR, OR SHAPE, THAT DIFFERENCE
GRASPS THE
VIEWER'S
ATTENTION. →

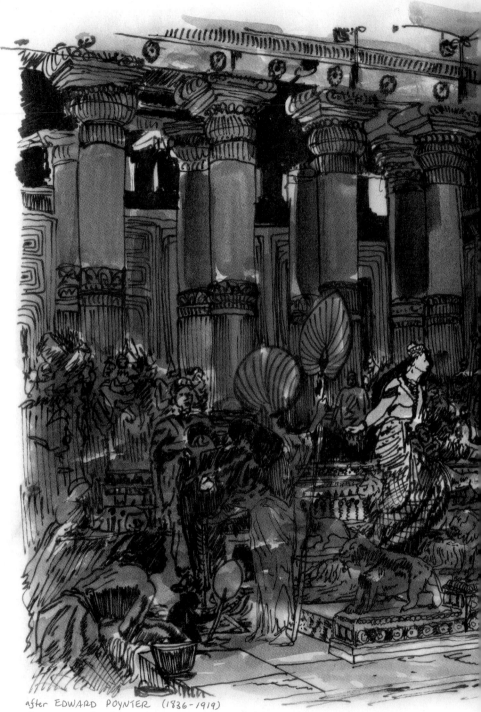

after EDWARD POYNTER (1836-1919)
THE VISIT OF THE QUEEN OF SHEEBA TO KING SOLOMON

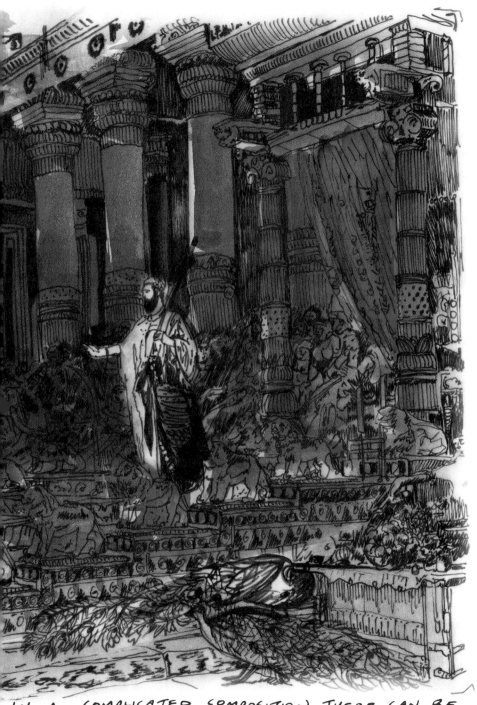

IN A COMPLICATED COMPOSITION THERE CAN BE
MANY FOCAL POINTS. BUT...

...DON'T OVERTHINK IT

USE **3** TO **5** ELEMENTS TO VISUALLY GUIDE A VIEWER THROUGH A COMPOSITION.

COUNTING OUT WHAT WOULD BE THE 10TH, 13TH, OR 39TH POSITION IS TOO MUCH THINKING.

A SIMPLE **1, 2, & 3** RANKING IS A GOOD HIERARCHY.

4, 5 & 6 MAY BE NECESSARY FOR A LARGE NUMBER OF ELEMENTS, BUT USUALLY A DESIGN READS IN A SPLIT-SECOND SO 39 STEPS BECOMES A NIGHTMARE TO SOLVE.

ORGANIZE FOR A SIMPLE, CLEAR PROGRESSION AND COHERENT WHOLE.

SUMMARY

Order in the composition! Rule number one: Don't confuse the viewer!

Use an interaction of contrasting elements to create a visual hierarchy. Establish the focal point and descending visual hierarchy to guide the viewer along a path and through a design to its end. Good hierarchy rules!

EXERCISES
& PROJECTS

1. REVERSE CAMOUFLAGE

INDIVIDUAL OR GROUP ACTIVITY

A. STAND OUT: The purpose of camouflage is to eliminate contrast—to blend into surroundings—for strategic purposes. A focal point is the direct opposite of camouflage. The purpose of a focal point is to bring attention for a specific purpose, such as to start a story or capture attention in a crowd (or design).

SUPPLIES: As needed in the setting; camera to record the scene.

COMPOSE AND SHARE RESULTS

- Create a situation in which you become the focal point in an actual interior or exterior environment.
- Think strategically. Contrast must be strong to create a focal point.
- Ask: Why are you the focal point? Is there a message?
- Photograph results; share with a group and critique.

2. THE SQUARE WHO WOULD BE KING

INDIVIDUAL ACTIVITY

A. GET IN SHAPE: Create a visual hierarchy using black dots, lines, and the following basic shapes:
- One square (make this shape the focal point)
- Three or more circles
- Three or more triangles

SUPPLIES: Computer and graphics software, desktop printer and paper.

COMPOSE AND SHARE RESULTS

- Establish the format size. 13" x 19" vertical recommended.
- Prioritize and organize the shapes. Black only.
- Arrange the shapes in composition.
- Share results with a group and critique success.
- Variations: 1. Add color and / or texture.
 2. Change the size of the format.

3. MAKE THE DIALOGUE MEANINGFUL

INDIVIDUAL ACTIVITY

A. DOWN THE RABBIT HOLE: Using the following three lines (or just the last line) of dialogue from *Through the Looking Glass* by Lewis Carroll, create three unique visual hierarchies:

"When I use a word," Humpty Dumpty said, in rather a scornful tone, "it means just what I choose it to mean—neither more nor less."

"The question is," said Alice, "whether you can make words mean so many different things."

"The question is," said Humpty Dumpty, "which is to be master—that's all."

SUPPLIES: Computer and graphics software.

COMPOSE AND SHARE RESULTS

- Organize the dialogue in a composition.
- Do not use illustrations. Design with only the letters, punctuation, color, and texture, and simple lines or shapes such as a border.
- Change the visual hierarchy in each composition in order to manipulate importance and meaning.
- Share results with a group and critique success.

YOU 'N' ME IN

UNITY

AND

RHYTHM

ESTABLISH
RELATIONSHIPS

COME TOGETHER

BOOGIE TO THE BEAT

REPEAT

CONTRAST

DESIGNERS USE CONTRAST TO ESTABLISH HIERARCHY AND ADD VISUAL VARIETY TO THEIR WORK.

PEOPLE LOVE VARIETY (IN COLOR, LINE, SHAPE, SCALE, TEXTURE, AND FOOD!)

BUT TOO MUCH VARIETY CAN FEEL CHAOTIC.

RETURN TO GESTALT THEORY: THE HUMAN BRAIN LIKES TO ORGANIZE WHAT IT SEES INTO A COMPLETE AND COHERENT WHOLE.

after WAYNE THIEBAUD (1920-)

☰ VS. ☰ UNITY

DESIGNERS USE UNITY
TO CREATE A SENSE OF
COHESIVENESS. WHEN
THE ELEMENTS
IN A PIECE
RELATE IN
ONE OR MORE
WAYS, THEY
SEEM TO
HARMONIZE.

BUT TOO MUCH UNITY
CAN BE BORING.

THE SOLUTION:
USE CONTRAST AND UNITY

CREATE
HARMONIOUS RELATIONSHIPS

To achieve **UNITY** within a strong visual hierarchy, create relationships among elements using:

1. REPETITION

REPEAT SIMILAR COLORS, SHAPES, VALUES, TEXTURES, OR LINES THROUGHOUT A COMPOSITION TO CREATE A VISUAL RELATIONSHIP BETWEEN THE ELEMENTS.

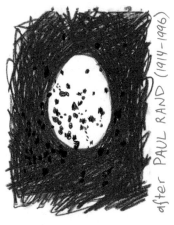

PATTERNS CREATE STRONG VISUAL UNITY. SO DOES ONE CONTINUOUS HUE COVERING THE BACKGROUND PLANE OF A COMPOSITION.

after PAUL RAND (1914-1996)

2. ALIGNMENT

LINES AND SHAPES THAT POINT TO EACH OTHER IN A CIRCULAR OR CRISSCROSS DIRECTION WITHIN A FORMAT TIE EACH OTHER TOGETHER.

USE IMPLIED LINES OR EDGES OF SHAPES TO CREATE PATHS OF ALIGNMENT.

ALIGNED SHAPES FEEL STABLE AND COHESIVE.

3. SIMILARITY

DIFFERING ELEMENTS WITH SIMILAR PHYSICAL CHARACTERISTICS APPEAR UNIFIED. TAKE 10 DIFFERENT SHAPES, MAKE THEM ALL BLUE, THEY WILL LOOK LIKE THEY BELONG TOGETHER.

PLACE A BORDER AROUND A GROUP TO HEIGHTEN THE SENSE OF COHESIVENESS.

after PAULA SCHER (1948–)

④. PROXIMITY & CONTAINMENT

Group HUG! CLUSTERING DIFFERENT SHAPES TOGETHER MAKES THEM APPEAR UNIFIED BECAUSE OF THEIR PHYSICAL CLOSENESS.

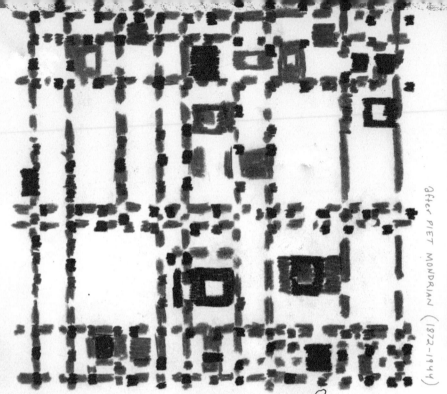

Establish the Beet

REPEATING COLOR AND/OR SHAPE ACROSS AND AROUND A COMPOSITION, PAUSING AT A POINT OF CONTRAST, THEN STARTING BACK UP & MOVING ALONG CREATES A NOTICABLE PULSING **RHYTHM** WITHIN THE COMPOSITION.

AS THE EYE MOVES AROUND A COMPOSITION, THE AMOUNT OF DIFFERENT COLORS — AND/OR SIZES OF ELEMENTS — EITHER INTENSIFIES OR SLOWS THE VISUAL BEAT.

SO, WANT TO BACHATA OR CHA-CHA OR FOXTROT?

RHYTHM, SPEED, AND INTENSITY DEPEND ON WHAT NEEDS TO BE COMMUNICATED.

WHY UNIFY?

DESIGNERS USE <u>UNITY</u> TO CREATE COHESIVENESS WITHIN A TINY
DESIGN SUCH AS A LOGO, AND WITHIN LARGER COMPOSITIONS
LIKE POSTERS, BROCHURES, AND WEBSITES. THEY ALSO USE IT
TO UNIFY ONE DESIGN ACROSS A VARIETY OF DIFFERING
FORMATS: ON PAPER, SCREEN, PACKAGES, BILLBOARDS, AND SO ON.

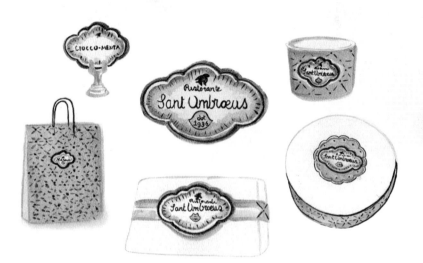

FOR INSTANCE: VISUAL IDENTITY SYSTEMS FOR BUSINESSES
AND ORGANIZATIONS DEPEND ON A SENSE OF UNITY TO
CREATE BRAND RECOGNITION ACROSS MULTIPLE DESIGN
FORMATS THAT MUST COMPETE WITHIN A CROWDED
MARKETPLACE. TIFFANY'S TRADEMARK BLUE OR
COCA-COLA'S WHITE SCRIPT LETTERING AND SIGNATURE
RED ARE INSTANTLY RECOGNIZABLE BECAUSE
THESE ELEMENTS APPEAR ON ALL THEIR WEBSITES, ADS,
PACKAGING, SIGNAGE, ETC.

157

ARTISTS USE ELEMENTS IN SIMILAR WAYS ACROSS MANY of their IMAGES TO CREATE CONTINUITY AND A STYLE for WHICH THEY GAIN RECOGNITION. PICASSO HAD MANY STYLES SUCH AS HIS Blue PERIOD & CUBISM. WAYNE THEBAUD USES LUSH COLORS for ALL HIS IMAGES of PASTRIES AND CANDIES.

UNIFYING the ELEMENTS MAKES them feel TIGHT AND ALL RIGHT!

SUMMARY

Unity is useful. Unity balances contrast. Unified compositions feel cohesive and harmonious. Rhythmic repetition creates a pulsing dance along the compositional line of vision. Communicate cohesively by connecting content across formats. We got the beat!

EXERCISES
& PROJECTS

1. CONTINUITY & CORRESPONDENCE

INDIVIDUAL ACTIVITY

A. BACKGROUND CONTINUITY: A single, continuous color used in the background of a composition can unify the disparate elements layered over it.

SUPPLIES: Color paper, cutting tools, and adhesives or computer and graphics software.

COMPOSE AND SHARE RESULTS

- Select a color palette of split complements and one or two neutrals.
- Use an 8" x 10" minimum size, vertical format.
- Make the background plane one hue.
- With the remaining colors, compose a variety of non-objective shapes over the single color. When composing the shapes, consider the interactions between the edges, margins, and all areas within the format. The composition should have a lead focal point and hierarchy. Lead the viewer in and around the composition. Create a rhythm for the viewer using secondary focal points.
- Share results in a group critique to determine success of the principles of composition.

INDIVIDUAL ACTIVITY

B. CORRESPONDING ELEMENTS: Repetition of a color, texture, and/or shape throughout a composition can unify the whole. Repeating a color palette and similar shapes (or subject matter) can create unity across many different compositions. For instance, the painter Wayne Thiebaud (1920 –) uses lush colors for all his images of pastries, pies, and candies.

SUPPLIES: Color paper, cutting tools, and adhesives or computer and graphics software.

COMPOSE AND SHARE RESULTS

- Select one color palette for three separate compositions.
- Use an 8" x 10" minimum size, horizontal format.
- Select domestic kitchen tools or carpentry tools for the subject matter.
- Create three separate compositions that each use the shapes in a pattern.
- For variety, vary the dominant color in each composition.
- All three compositions should feel unified but distinct.
- Share results in a group critique to determine success.

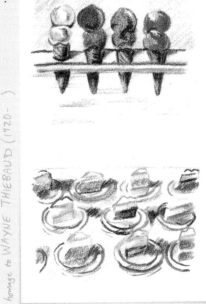

homage to WAYNE THIEBAUD (1920 –)

BALANCING ACTS

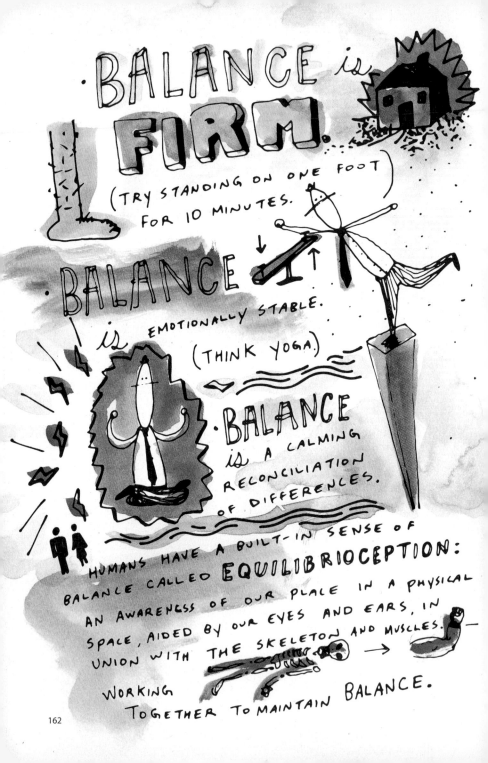

BALANCE is FIRM.

(TRY STANDING ON ONE FOOT FOR 10 MINUTES.)

BALANCE is EMOTIONALLY STABLE.

(THINK YOGA.)

BALANCE is A CALMING RECONCILIATION OF DIFFERENCES.

HUMANS HAVE A BUILT-IN SENSE OF BALANCE CALLED EQUILIBRIOCEPTION: AN AWARENESS OF OUR PLACE IN A PHYSICAL SPACE, AIDED BY OUR EYES AND EARS, IN UNION WITH THE SKELETON AND MUSCLES. WORKING TOGETHER TO MAINTAIN BALANCE.

EQUILIBRIOCEPTION

ENSURES PEOPLE DON'T **FALL FLAT** ON THEIR **FACES** WHEN STANDING OR WALKING.

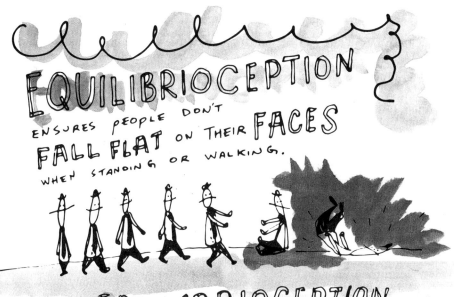

POOR EQUILIBRIOCEPTION

LEADS TO DISORIENTATION, NAUSEA, AND VERTIGO — BOTH IN LIFE & ART.

OUR MINDS AND HEARTS (AND DESIGNS) CRAVE EQUILIBRIUM.

BALANCE = PEACE

NOTE:
THE CHINESE TAOIST PHILOSOPHY OF **YIN YANG** SAYS THAT OPPOSITE OR CONTRARY FORCES ARE INTERCONNECTED AND INTERDEPENDENT IN THE NATURAL WORLD AND WE DO BEST TO SEEK THIS TYPE OF BALANCE.

THINK OF NATURE'S PHYSICAL DUALITIES:
- LIGHT & DARK
- MOUNTAIN & VALLEY
- FIRE & WATER
- MALE & FEMALE
- LIFE & DEATH

VISUALIZING BALANCE

IN THE PHYSICAL WORLD, BALANCE IS CREATED THROUGH AN EVEN DISTRIBUTION OF THE **WEIGHT** OF OBJECTS. IN ART AND DESIGN, BALANCE IS CREATED THROUGH AN EQUAL DISTRIBUTION OF THE **VISUAL WEIGHT** OF THE ELEMENTS IN A COMPOSITION.

WHEN ARRANGING VISUAL ELEMENTS, THERE IS A TENDENCY TO PLACE THE "HEAVIER" ELEMENTS ON THE BOTTOM AND THE "LIGHTER" ELEMENTS AT THE TOP OF THE COMPOSITION — INSTINCTIVELY APPLYING THE LAWS OF THE PHYSICAL WORLD.

Side Note:

IN PHYSICS, WE BALANCE TWO OBJECTS OF DIFFERENT WEIGHTS BY PLACING THE LARGER ONE CLOSER TO THE CENTER. THIS PRINCIPLE ALSO APPLIES TO DESIGN.

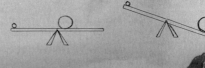

after JØRN UTZON (1918-2008)

BUT BALANCE IS ALSO A STATE
OF EQUILIBRIUM AND TENSION, A
PUSH AND PULL, A WEIGHING AND
COUNTER WEIGHING OF THE
ELEMENTS, A CRISSCROSS
ARRANGEMENT OF OPPOSING
FORCES THAT NEUTRALIZE OR
RECONCILE EACH OTHER.

FINDING THIS COUNTERPOISE
IS A PROVOCATIVE, MADDENING,
FUN CHALLENGE.

WEIGHING IN

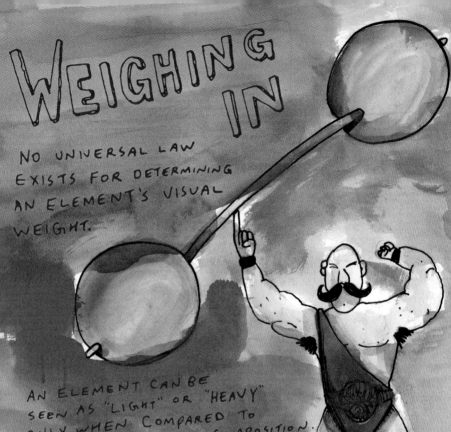

NO UNIVERSAL LAW EXISTS FOR DETERMINING AN ELEMENT'S VISUAL WEIGHT.

AN ELEMENT CAN BE SEEN AS "LIGHT" OR "HEAVY" ONLY WHEN COMPARED TO OTHER ELEMENTS IN A COMPOSITION.

BUT THERE ARE SOME BEST PRACTICE SITUATIONS. FOR EXAMPLE, ELEMENTS THAT CAPTURE THE MOST

ATTENTION IN ANY COMPOSITION ALWAYS APPEAR TO BE HEAVIEST. AS ELEMENTS DIMINISH IN IMPORTANCE, THEY APPEAR LIGHTER.

Hot Seat — Knoll — after WOODY PIRTLE (1944–)

CALIFORNIA PUBLIC RADIO / RADIO PUBLICA DE CALIFORNIA — after MICHAEL VANDERBYL (1947–)

ALSO:

- THICK LINES FEEL HEAVIER THAN THIN ONES.

- A HEAVY ELEMENT "POINTING" TO LIGHTER ELEMENTS TRANFERS ATTENTION TO CREATE BALANCE.

- SHADES FEEL HEAVIER THAN TINTS.

- A SMALL AMOUNT OF AN INTENSE COLOR BALANCES A LARGER, DESATURATED COLOR.

- WARM HUES FEEL HEAVIER THAN COOL ONES.

- HIGHLY TEXTURED ELEMENTS FEEL HEAVIER THAN SMOOTHER ELEMENTS.

- A COMPLEX SHAPE FEELS HEAVIER THAN A SIMPLER ONE BECAUSE OF ITS MANY FEATURES.

- ONE LARGE NEGATIVE SHAPE BALANCES MANY SMALLER POSITIVE SHAPES.

- GROUPS OF SIMILARLY SIZED ELEMENTS CAN BALANCE ONE LARGER ELEMENT.

- AN ISOLATED ELEMENT (A FOCAL POINT) CARRIES CONSIDERABLE WEIGHT.

- THE CENTER OF A COMPOSITION IS LIGHTER THAN ELEMENTS PLACED ALONG THE EDGES.

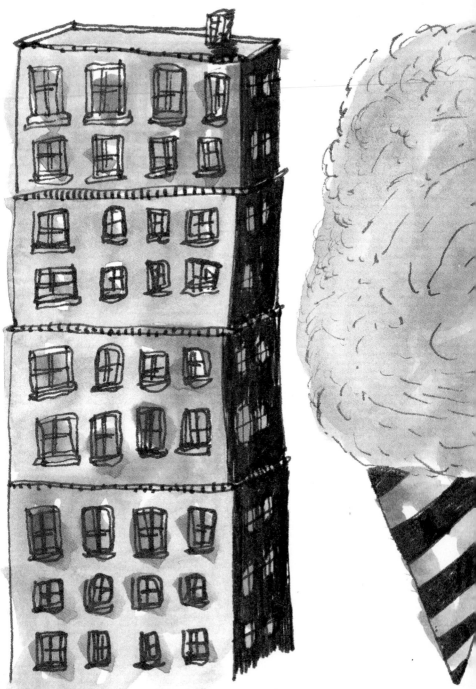

AND FINALLY...

INSTINCTIVELY APPLYING LAWS OF THE PHYSICAL WORLD, OUR MIND ASSIGNS WEIGHTS TO VIRTUAL OBJECTS BASED ON THEIR ACTUAL WEIGHT. A DRAWING OF A BUILDING AND COTTON CANDY CAN BE THE SAME SIZE AND COLOR WITHIN A COMPOSITION, BUT THE BUILDING WILL USUALLY SEEM HEAVIER.

BALANCE COMES IN FOUR FLAVORS:

1. SYMMETRICAL
2. ASYMMETRICAL
3. RADIAL
4. CRYSTALLOGRAPHIC

TURN THE PAGE!

BALANCE BEAM

1. SYMMETRICAL BALANCE,

OR FORMAL BALANCE, IS THE MIRRORING OF
VISUAL ELEMENTS ALONG A CENTRAL AXIS.

NATURE IS AWASH IN SYMMETRY.

FLOWERS, SEASHELLS, SNOWFLAKES, AND
BUTTERFLIES ARE SYMMETRICAL.

After LEONARDO DA VINCI (1452-1519)

HUMAN BODIES ARE ALSO
MOSTLY SYMMETRICAL, DESPITE
THE OCCASIONAL CROOKED NOSE.

PEOPLE LOVE SYMMETRY. IT'S INNATE.

How does symmetry feel?

SYMMETRY ACHIEVES ORDER THROUGH A PERFECTLY
EQUAL OR EVEN DISTRIBUTION OF ELEMENTS, CREATING
A FEELING OF STABILITY AND PEACE IN THE VIEWER

- Symmetry also feels formal and proper.
- Symmetry feels structured and strong.
- Symmetry can even be therapeutic.

The emperor Shah Jahan (1592-1666) had the Taj Mahal built with perfect symmetry in an attempt to restore some of the (emotional) balance gone from his life when his wife Mumtaz (1593-1631) died.

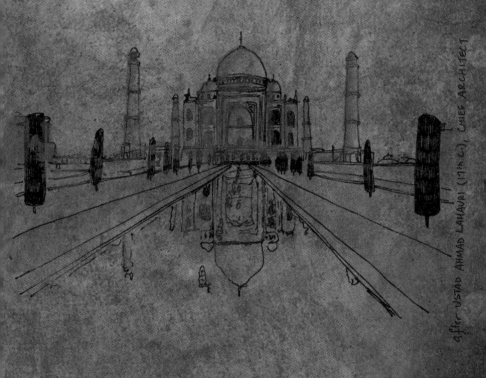

after Ustad Ahmad Lahauri (17th c.), chief architect

But:
Symmetry is also stiff and static.
Symmetry can be repetitive.
Symmetry can be boring & predictable.

Yawnn

After Robert McGinnis (1926–)

ASYMMETRY IS OFTEN A PERSONAL JUDGEMENT— SOMETHING YOU FEEL IN YOUR GUT.

NOT EVERYONE WILL AGREE A GIVEN ASYMMETRICAL COMPOSITION IS IN BALANCE.

2. ASYMMETRICAL BALANCE,

OR INFORMAL BALANCE, IS ACHIEVED BY
PLACING DIFFERENT ELEMENTS OF SIMILAR
VISUAL WEIGHT ON EITHER SIDE OF AN AXIS.
PICTURE A 10LB. WEIGHT ON ONE SIDE OF
A SCALE AND TWO 5LB. WEIGHTS ON THE OTHER.
THE SHAPES (OR NUMBER OF SHAPES) ON EITHER
SIDE ARE DIFFERENT, BUT APPEAR BALANCED.

THE DISPARATE ELEMENTS WORK DYNAMICALLY
TOGETHER TO FORM A **UNIFIED WHOLE**
(see earlier notes on GESTALT PRINCIPLES.)

MORE ASYMMETRICAL BALANCING ACTS:

- A FEW LARGE SHAPES BALANCE SEVERAL SMALLER ONES.

- BLUE IS IN BALANCE WITH ORANGE OR ITS SPLIT COMPLEMENT: RED/ORANGE / YELLOW/ORANGE.

- A HAIRY, DIAGONAL LINE BALANCES SMOOTH, STRAIGHT LINES.

How does asymmetry feel?

- ASYMMETRY FEELS NATURAL AND RELAXED, NOT CONTRIVED.

- ASYMMETRY FEELS DYNAMIC.

- ASYMMETRY IS SOPHISTICATED.

- ASYMMETRY FEELS UNEXPECTED.

BUT: ASYMMETRY IS ALSO MADDENINGLY DIFFICULT TO ACHIEVE WITH NO GUARANTEE THAT VIEWERS WILL SENSE THE BALANCE

At the center of the composition.

Think: Sun rays.

Essentially this arrangement is symmetrical.

Clocks, daisies, and wagon wheels have radial balance.

How does radial balance feel?

Radial balance moves, spins is simple and playful.

Caveat: Radial balance is difficult to read. Staring at radial balance on screen can cause sickness.

Think: Headaches

3.

Radial balance
is an equal
horizontal, diagonal,
and vertical distribution
of visual
elements around
a single
central point,
dot, or line.

Elements seem
to emanate from
this point
usually

4. CRYSTALLOGRAPHIC BALANCE,

OR ALL-OVER BALANCE, IS THE EQUAL AND REGULAR DISTRIBUTION OF ALL VISUAL ELEMENTS AND WEIGHTS ACROSS A COMPOSITION. THERE'S NO FOCAL POINT OR HIERARCHY. THINK: **PATTERN.**

after ANDY WARHOL (1928-1987)

CHECKERBOARDS AND QUILTS AND CHECKERBOARD QUILTS, AND SOME PAINTINGS OF JACKSON POLLOCK AND ANDY WARHOL HAVE ALL-OVER BALANCE.

How does all-over balance feel?

- CRYSTALLOGRAPHIC BALANCE FEELS HOLISTIC.
- CRYSTALLOGRAPHIC BALANCE FEELS CONTEMPLATIVE.

BUT. CRYSTALLOGRAPHIC DESIGN MIGHT LOOK LIKE VAPID WALLPAPER — REPETITIVE. AND MONOTONOUS. IN THE CASE OF ANDY WARHOL, THE MONOTONY IS PURPOSEFUL — A CRITIQUE ON THE REPETITION OF MATERIAL CONSUMPTION.

POP QUIZ!

HOW IS EACH BALANCED?

Winston Churchill
The Wilderness Years

Mobil

1. _____

2. _____

I. KUNSTAVSSTELLVNG
DER VEREINIGUNG BILDENDER KUNSTLER ÖSTERREICHS.
SECESSION
ERÖFFNUNG ENDE MÄRZ
SCHLUSS MITTE JUNI.
I. PARCRING ·12·
GEBÄUDE DER K·K· GARTENBAU GESELLSCHAFT.

3. _____

4. _____

5. _____

6. _____

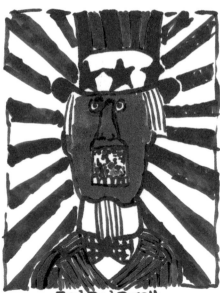

7. _____

8. _____

SUMMARY

Humans need and also crave balance to feel secure and composed in life as well as in art. Without balance we feel dizzy and out-of-sorts. But achieving balance in art and design—whether symmetrical, asymmetrical, radial, or crystallographic—is often an intuitive game of weight and see. Look at your visual elements closely. How do they feel? You may not be able to set them on a scale to determine their exact weight, but you can feel how much they weigh in relation to one another and place them in your design accordingly to create balanced, strong compositions.

EXERCISES
& PROJECTS

1. FINDING BALANCE

INDIVIDUAL ACTIVITY

A. BALANCE ABOUNDS: Balance is all around us. Nature likes it, and so do we. Look around your environment—both natural and man-made— for examples of balance (or imbalance). Find examples from each of the major categories of balance: symmetrical, asymmetrical, radial, and crystallographic.

SUPPLIES: A digital camera and a computer with graphics software.

COMPOSE AND SHARE RESULTS

- Explore both natural and built environments for examples. Balance is created by both nature and by man.
- Photograph your findings. Select as many as needed to exemplify the types found in each category.
- Save the categorized shapes in a digital file.
- Share results with the class. Compare and contrast how balance is created naturally versus by man.

2. ELEMENTS IN BALANCE

INDIVIDUAL ACTIVITY

B. BALANCE AND SHAPE: Regardless of their weight in the physical world, all shapes have visual weight within a composition.

SUPPLIES: Various colored and textured paper and fabrics, scissors or X-Acto knife, digital camera.

COMPOSE AND SHARE RESULTS

- Choose paper and fabrics that have different textures and patterns. Cut out shapes of all different sizes from the substrates. Consider all the different kinds of shapes, including geometric, organic, formal, etc., and cut those shapes in varying sizes.
- Arrange the shapes on a blank sheet of paper to create the various forms of balance. Use different combinations and amounts of the shapes to explore how balance can be achieved.

- Get crazy and let fate decide the balance! Take the shapes and toss them up in the air, letting them fall where they may on the page, resulting in a completely random composition.
- Photograph the compositions and save the categorized examples in a digital file.

Share results with the class. Compare and contrast how balance is achieved through manipulation of the shapes. How do geometric shapes weigh against more organic ones? Which colors have a greater visual weight? Do the methodical layouts vary from the random ones? How?

3. BREAKING BALANCE

INDIVIDUAL ACTIVITY

A. HELLO, GOODBYE, SYMMETRY: Images created for the famous Rorschach Test are usually used for psychoanalysis. But they are excellent examples of nonobjective, symmetrical imagery.

SUPPLIES: White (or light) paper, dark ink or paint, scissors or X-Acto knife, glue or tape, scanner, printer.

COMPOSE AND SHARE RESULTS

- Lay out the sheets of white paper on a flat, even surface.
- Carefully pour (or "dribble") a small amount of paint or ink on the pages in random patterns. Fold the paper down the center and press the ink into itself, making sure to completely mash both halves together.
- Open the papers back up and let dry. The resulting image will be a random but symmetrical composition.
- Photograph or scan the compositions and save in a digital file.
- Print copies of the symmetrical compositions. Cut or tear the printouts to make new shapes. Be sure to vary the sizes.
- Take the resulting pieces and arrange them into new asymmetrical compositions.
- Photograph or scan the compositions and save in a digital file.

Share results with the class. Compare and contrast how balance is achieved through manipulation of the shapes. How was asymmetrical balance achieved from the remnants of the symmetrical compositions?

1. after RED & WHITE QUILTS NYC ARMORY SHOW
2. after IVAN CHERMAYEFF (1900-1996)
3. after GUSTAV KLIMT (1862-1918)
4. after HENRI MATISSE (1869-1954)
5. after FRANCES MACDONALD (1873-1921)
6. after ALEXANDER CALDER (1898-1976)
7. after CIPE PINELES (1908-1991)
8. after SEYMOUR CHWAST (1931-)

FINITE
AND
INFINITE
DESIGN

THERE ARE TWO TYPES OF DESIGN (& STUDY).
ONE TYPE COULD BE CALLED
FINITE, THE OTHER INFINITE.

A FINITE DESIGN HAS ONLY ONE SOLUTION.
AN INFINITE DESIGN CAN BE
CREATED AND INTERPRETED
IN MANY WAYS.

WANT TO CREATE AN
INFINITE SOLUTION?

DESIGN ON.

INDEX

WELCOME TO OUR INDEX. FOR A GLOSSARY OF TERMS, VISIT DESIGN-FUNDAMENTALS.COM